FUN WITH PENCIL

ANDREW LOOMIS

DEDICATED TO EVERYONE WHO LOVES A PENCIL

MR. WEBSTER DEFINES DRAWING
AS DELINEATION. THAT DOESN'T
TELL YOU HOW MUCH OF A REAL
"BANG" THERE IS IN IT. MAYBE
HE NEVER KNEW. MOST FOLKS
LOVE TO DRAW EVEN WHEN
THEY KNOW LITTLE ABOUT IT. IT
STARTED WITH THE CAVE MAN,
AND STILL SURVIVES ON THE
WALLS OF PUBLIC PLACES... BE-
CAUSE IT'S SO MUCH FUN, AND
SO EASY, IT'S A SHAME NOT TO BE
ABLE TO DO IT BETTER.

ANDREW LOOMIS

ALL THAT YOU NEED TO KNOW, TO START
THIS BOOK, IS HOW TO DRAW A CIRCLE. . . .

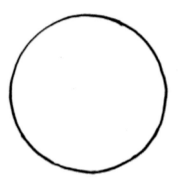

And it can be as lopsided as the family budget, and
still work out.

Don't start out with that old gag, "I couldn't draw a straight
line." Neither can I, freehand. If we need a straight line, we
can use a ruler. Now please try it, just for fun.

HOWDY FOLKS!

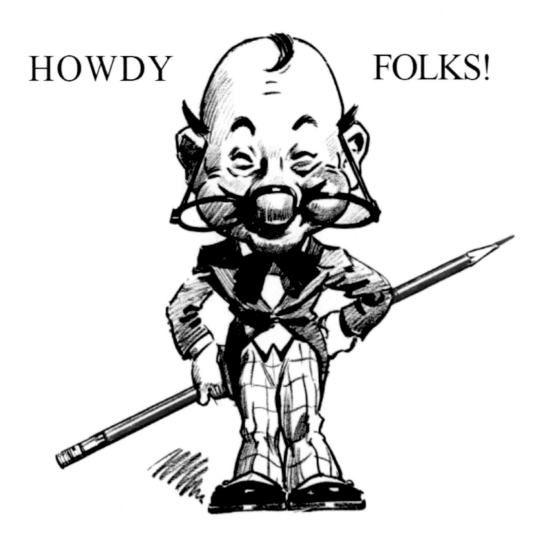

Who am I? Oh, just one of Andy's little funny folk.
But I'm important! He gave me a job. I'm the spirit
of the book, by jeeminy, big nose and all. I represent
all the blue in here. My right name would be Basic
Form, but that's much too high-sounding. He thinks
that name would scare you away. So he just calls me
"Professor Blook" and lets it go at that. Now, I've got
a few interesting things to tell you.

Since Andy cannot talk to you personally, he put me in here so we can really get together. It's tough on Andy, for that guy really loves to talk, especially "shop talk." Now this plan of action is based on the use of simple forms that are already known and familiar to you, and which you can certainly draw.

From these simple, known forms, we build other forms, which without some constructive plan would be too complicated to draw. For instance, the top of the head, or cranium, is nearer to a ball in shape than anything else. So we start with a bull, and add to it the shapes we want. We thus "arrive" at the outlines that are needed instead of guessing at them. Only the most talented end experienced artist can draw at once the final outlines. That procedure is most difficult, and is the reason most people give up drawing.

But knowing how to "construct" makes drawing simple and easy, and a delightful pastime to anybody. By building preliminary shapes and developing the outlines on them, we know WHERE TO DRAW OUR REAL LINES. There is hardly anything that cannot first be constructed by the use of simple forms.

"Santa had a belly, like a bowl full of jelly." Now that was a real observation. We know just whet it must hove looked like. In fact we can see it shaking! Now, the idea is to draw the bowl before the belly. If the observation is correct, it ought to be a simple matter to make it fairly convincing as an abdomen for old Nick. Of course we will cover it with his coat and pants, but we'll be pretty sure the pants don't spoil the big idea. I

picked on Santa because he'll never complain that I'm being too personal over his appearance. I might just as well have chosen your next-door neighbor, his lunch basket may be equally rotund, and shake some too. Every form is like some simpler form, with this or that variation, and with pieces added on. The simplest

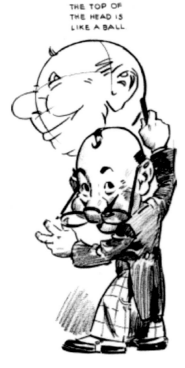

THE TOP OF THE HEAD IS LIKE A BALL

Forms we know are the sphere, the cube, and the egg. Before we could walk we recognized the sphere in Dad's new golf bulls; the cubes were in the sugar bowl; as for the eggs, well, the nicest ones were Easter eggs. I say, "Draw a line." You cannot know just what I mean. A straight line? A curved line? A jagged line? A wiggly line? There are a thousand kinds of lines; be more specific. But it I say draw a ball, a cube, an egg, a cylinder, a pyramid, a cone, a rectangular block, in each case the image you get is perfect. You know exactly what I mean. Instead of "line," we shall think in terms of concrete and tangible "form," and proceed as if we were handling lumps of clay. You can appreciate the value of such a method, for you know the fundamentals even before you start; they are obvious to anybody. If you never saw a ball, you should quit right now.

As you proceed to build all sorts of shapes out of simpler ones, it is amazing what you can do with them, and how accurate and "solid" the resulting drawings will appear. The surprising part is that, when the construction lines are erased, very few could guess how it had been done. Your drawing appears us complicated and difficult to the other fellow as mine might seem to you now. It takes on a look of professional workmanship, which indeed it has, since the professional artist has by some method had to "construct" his work to make it "professional."

If you will give the following pages even your amused attention, I am satisfied you will find much that will surprise you in the way of ability but perhaps you heretofore never guessed you had. If it absorbs your interest, you might find yourself clever enough to amaze those about you. Just now take my word for it that the method is simple, practical, and, I believe, possible for anybody to follow.

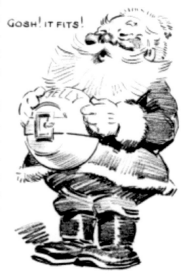

GOSH! IT FITS!

TAKE A GOOD LOOK AT THIS PAGE

A circle is a flat disk. If you draw the "inside" contours, it becomes a solid ball, with a third dimension. We shall build other forms, like lumps of clay, onto this solidity. The construction will be erased, but the solid appearance will remain, giving form or the appearance of reality.

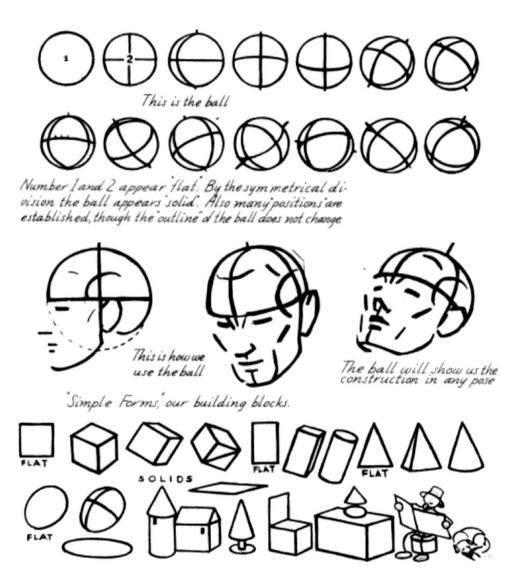

This is the ball

Number 1 and 2 appear "flat". By the symmetrical division the ball appears "solid". Also many "positions" are established, though the "outline" of the ball does not change.

This is how we use the ball

The ball will show us the construction in any pose

"Simple Forms," our building blocks.

FLAT

SOLIDS

FLAT

FLAT

FLAT

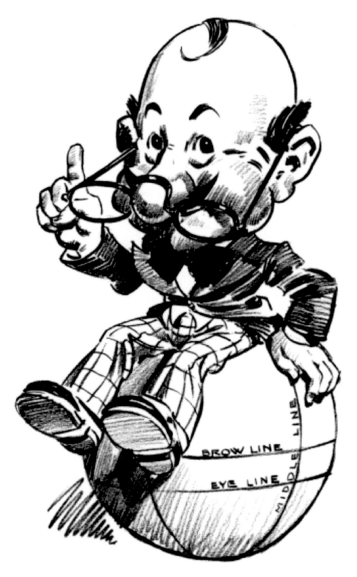

Get a pencil and paper quickly! Draw lightly all you see printed in blue. Take one stage at a time, on one drawing, until the last stage; then finish, with strong lines over the light ones, the lines we have printed in black. That is all there is to learn! These are "selected" or "built in" from the basic forms. I call the basic drawings "Blooks," after myself.

HERE WE GO!

I promised you that all you need to know, to start this book, is how to draw a lopsided ball. Whatever shape you draw can be used as a foundation for a funny face. Do the best you can, even if the ball looks more like a potato.

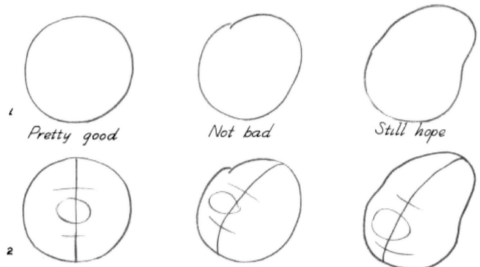

Pretty good *Not bad* *Still hope*

Divide the ball any way you wish. Add the nose in the middle. Then add crosslines above and below nose. Turn the ball if desired

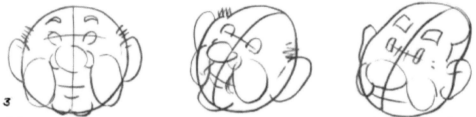

Add eyes, ears, mouth, brows, etc. Attach a couple of balls for cheeks. Draw lightly. Then select the lines you want and draw in heavily.

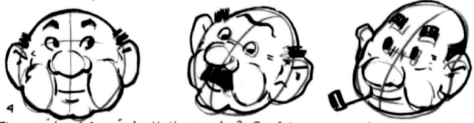

This is "building". Isn't it simple? Build your own. You need not copy.

THE FUN STARTS!

The big idea is to start with a "form." Then develop other "forms" on it. Build your final lines in by selecting, eliminating the lines you do not use. I leave mine in to show how it's done.

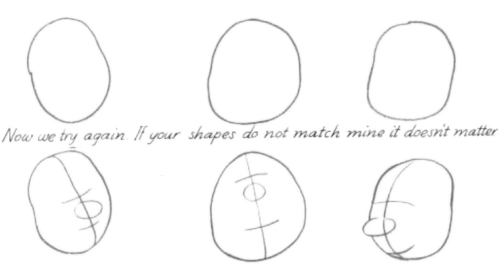

Now we try again. If your shapes do not match mine it doesn't matter

Any shape will do. Get the working principle. Remember the sides of the face should match. Do not make one cheek or ear larger than the other.

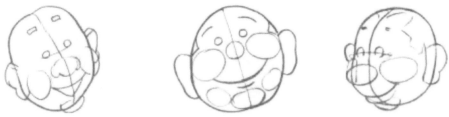

All blue lines are light lines. When drawn in as you want them, erase until faint, and then "bang" in the heavy lines for the final drawing

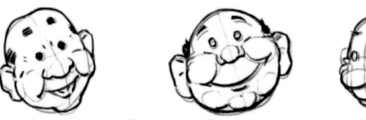

Draw fairly large. Since your shapes are your own, you "originate" faces.

A SURE METHOD FOR ANYBODY

These are happen heads, just plain 'Duck Soup' for you! They're easy

Draw four balls, all about the same size. They need not be real round

Now add a small ball. Place it anywhere inside or touching the first ball.

Divide the ball so that the division lines cross at a point under the nose.

Add crosslines above and below nose as you did before. Now "build in"

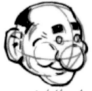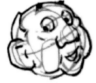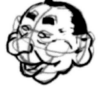

the rest. The ears always go on a line half way round the head from

the middle line of the face. Finish any way you wish. Lots of fun!

IT'S REALLY GOING TO BE EASIER THAN YOU EXPECTED

Now, if the first drawings you do are not the last word in cleverness, don't be discouraged. You will soon get the idea. When you begin to sense form, you will have the whole works. Then we'll polish up, and they will have to admit you are good.

 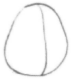

The middle line establishes the "solidity" of the form. The ultimate appearance of the drawing is the result of the basic forms you have built into it.

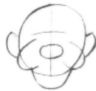 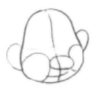 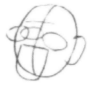 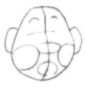

As you learn you can control the "type" of face by selecting shapes that give you the effect you want. You feel the expression even before finished

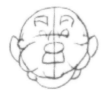 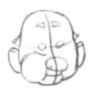 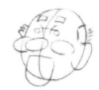

Most folks only learn to draw one face and do it until it bores them. This way you never get two alike, if you raise or lower, fatten or diminish, or invent the shapes you attach. You can vary the ball so many ways it also adds much variety.

By the time you go through the book you should be able to create almost any character you wish, tall, short, thin, fat, jolly, sad, angular, pudgy, bony, gawky, any old kind you want. But just now we'll develop the head. It's very important.

THE "BLOOK BALL"

If you will now turn back to page 12 and look at the string of balls, you will see that we are getting right into big business. You need some practice on these. Never mind if they are a little off.

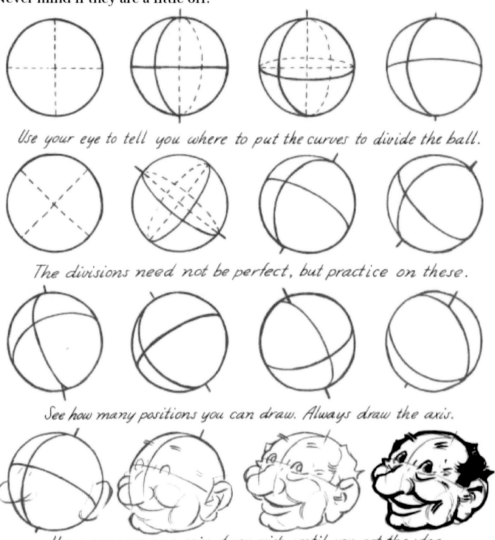

Use your eye to tell you where to put the curves to divide the ball.

The divisions need not be perfect, but practice on these.

See how many positions you can draw. Always draw the axis.

Use a compass or a coin, if you wish, until you get the idea.

The better you can draw these balls in any old position you wish, the better you are going to be. The line from the top to bottom is the "middle" line of the face. The horizontal line, which looks like the equator, is the "eyeline," and it also locates the ear.

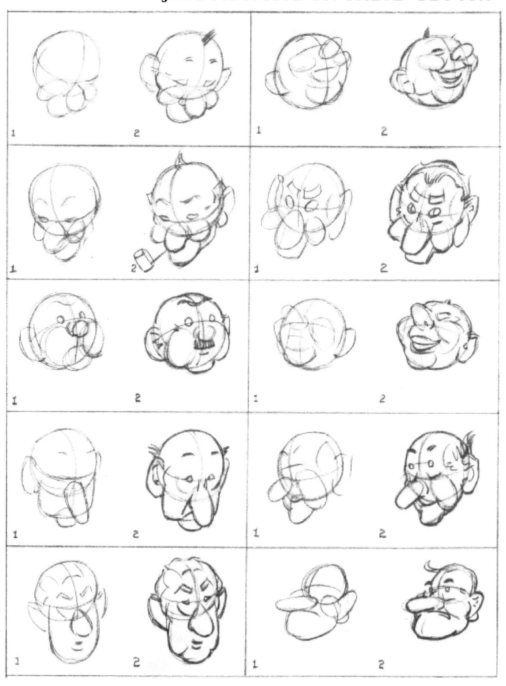

THE BEST WAY TO GO ABOUT IT

 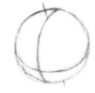

Draw the ball. Tilt it any angle

Attach nose, ears and chin

Now the eyes, mouth, cheeks, brow

Erase until faint. The built in shapes will suggest other details.

When it's all set "Poke in" the black.

WE ADD ANOTHER LINE TO THE BALL

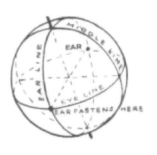

Look at the diagram. This last line goes completely around the ball, thought the axis at each end, and cuts the eyeline just halfway round on each side of the middle line. The ear joins the head at the point of intersection of the eyeline and the earline.

Sketch in the ball freehand.

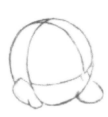 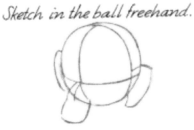 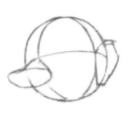

Place nose and ears.

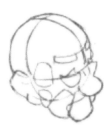 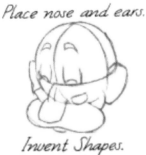

Invent Shapes.

THERE IS NO LIMIT TO THE VARIETY

I am a lot more anxious to have you understand the method and create your own forms than to copy mine. But copying mine now will get you started.

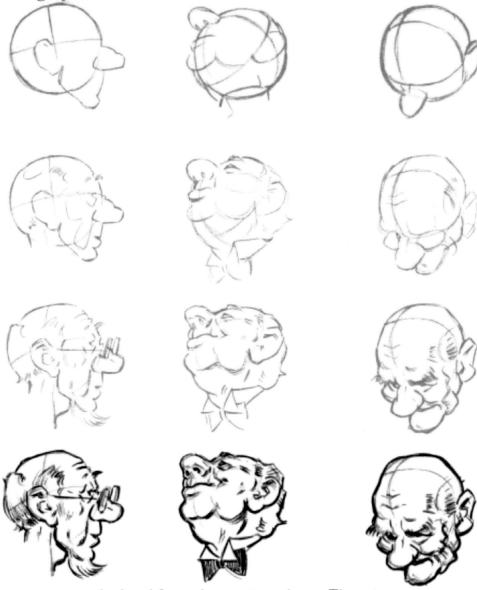

Always construct the head from the cranium down. There is no other satisfactory way. You can see by now that the position of the ball determines the pose of the head. The pieces you build on determine the character.

"BLOCKY" TREATMENT LENDS CHARACTER

"Blocky" shapes always combine interestingly with round shapes.
It is a good idea to make the final lines angular even around curves.
It gives a sense of bone and ruggedness of character. You would
not do this when drawing pretty girls or babies.

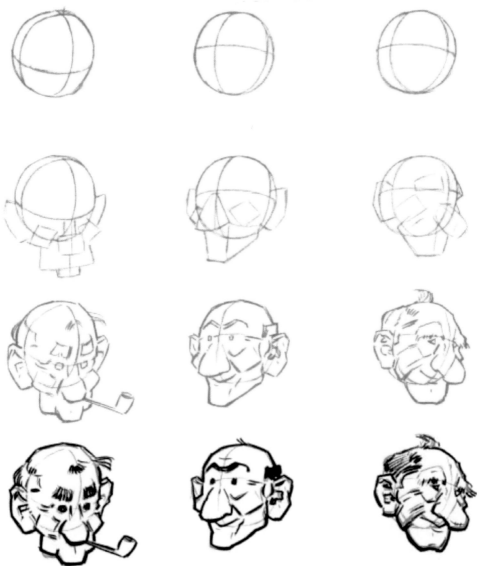

Now I've got a surprise for you. Instead of drawing all there
lunkheads, let's try something real. I'm going to pose for you.

BLOOK POSES

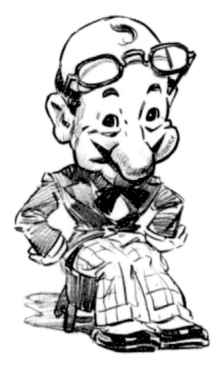

You didn't suspect it, but I've been lookin' right over your shoulder, all the time. No kiddin', folks, you are all gettin' good. I believe by now you are not nearly so dubious. So now just try one of me and surprise yourself. Really, I'm easy to do.

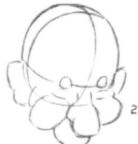

Now here is the position of the ball. Draw it carefully.

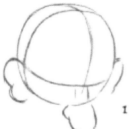

1

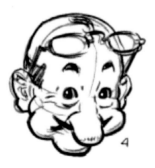

2

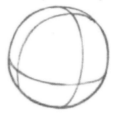

3

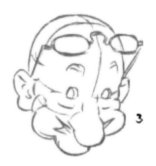

4

There now! Didn't I tell you I'd make an artist of you in no time? Now folks you've just had your first taste of the fun that's in this business. Keep goin' but please don't be satisfied. The real fun is all ahead!

EXPRESSION

Expression is a matter of personal interpretation and is the biggest stickler for the average funster. So I have prepared an Expression Chart for your ready reference. Every face varies, of course, but there are fundamental things that happen in the face for every kind of emotion. A fat man looks surprised in about the same way as a thin fellow. He does the same things with a different face. These will show you the basic action of the features. Another artist might interpret these differently but they are something to go on.

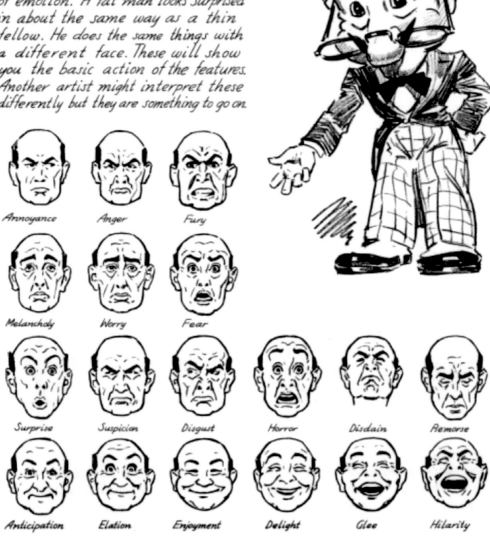

Annoyance Anger Fury

Melancholy Worry Fear

Surprise Suspicion Disgust Horror Disdain Remorse

Anticipation Elation Enjoyment Delight Glee Hilarity

EXPRESSION

The Smile

The ball

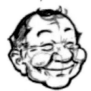

The pieces

Mouth and eyes

Other details

The main characteristics of the smile are squinting of the eyes, fold under eyes. The pieces are full and point toward the ear. Mouth wide, fits between pieces.

The Laugh

Tip ball back

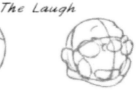

The pieces

Worked out

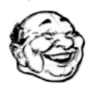

Finished

For the laugh, squeeze the cheek high against the eye, tilt eyes at outside corners. Folds under the eyes. Pull corners of mouth well up. Show upper teeth only

The Frown

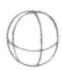

Tip ball down

The pieces

Sour enough

to pickle lemons

Sour faces and frowns work out so much better if built of angular or blocky shapes. Remember "anger" as associated with "angular." Try out some "pieces" of your own. Fun!

Really Furious

Tip ball down

The pieces

Snarling Papa

and how!

Pop the eyes. Distend nostrils. Show teeth. Pull cheeks forward and down Open corners of mouth wide and pull way down. These drawings are based on the "Expression Chart." Try others.

I think it's fun to create a little face and then see what we can make it do. Expression will be of great value. Soon you will want to draw a continuity of action in several pictures.

In surprise, anxiety, pity, elation, fear, anticipation, delight, the brows are elevated. The brows are important. We speak of "knitted brow", "worried brow", "troubled brow", etc. Study your own.

In doubt, perplexity, suspicion, disgust, disdain, annoyance, anger, fury, concentration, and in hilarious laughter, the brows point down. There are many subtle emotions. Study them.

When it's all said and done, you must "feel" the expression you want. Make faces at yourself in a mirror. If anybody catches you, claim that you are smart and they are crazy.

TRICK STUFF

Try this on the folks. Tell them draw two overlapping circles, any size. Draw a middle line through both and build on your own pieces. You can make a head out of any combination. Of course, tell them to draw lightly.

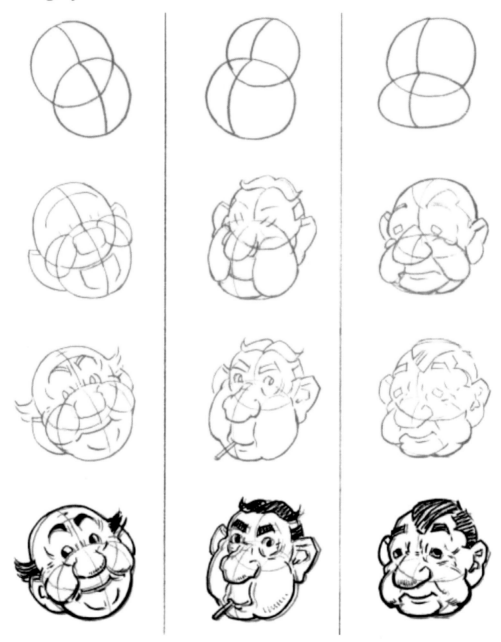

TRICK STUFF

Draw a circle. Attach two smaller circles, not far apart, anywhere. You can put a third above and between them. Then draw the middle line so it passes between the two small circles. Proceed as usual.

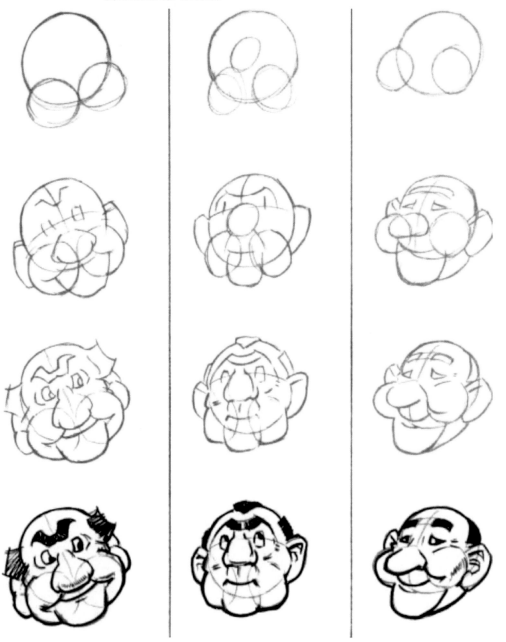

HERE'S A STUNT

Draw three balls, one of them small, in any position. Connect the larger balls. Draw a middle line under the small ball. This suggests a head. Now use your imagination to complete the drawing.

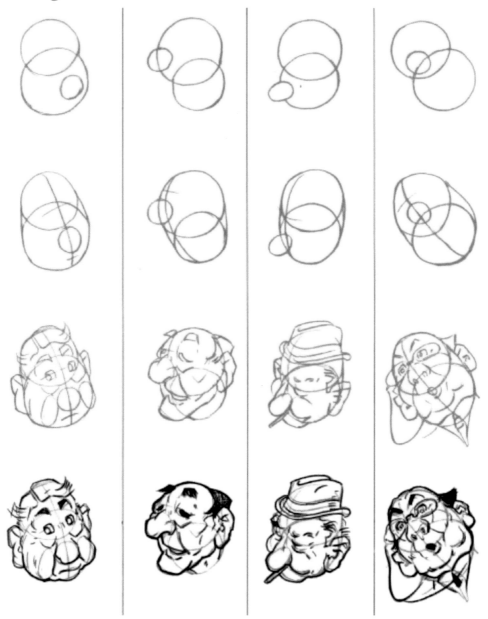

DON'T MISS THIS PAGE

Here we combine the ball with other basic forms. With "solid forms" to build on, the head begins to take on more reality. You can almost anything you want to with the supplementary forms, and come out all right. The is real character drawing, and a challenge to you.

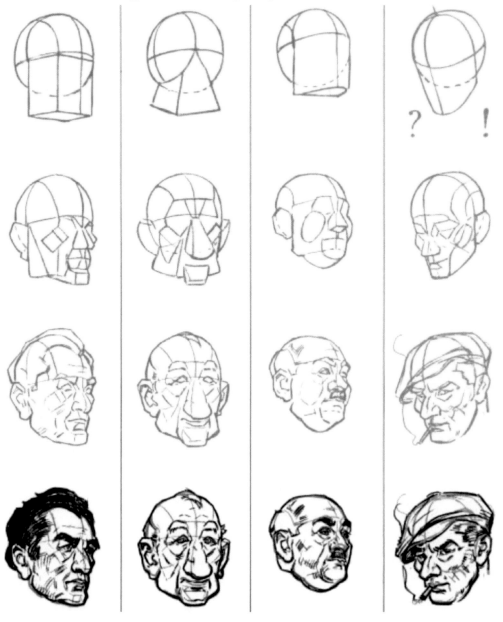

PROJECTION

This page is for the clever folks. It is a method of projecting the characters you have created into various poses. Try it with very simple heads at first. You must use your eye and build very carefully.

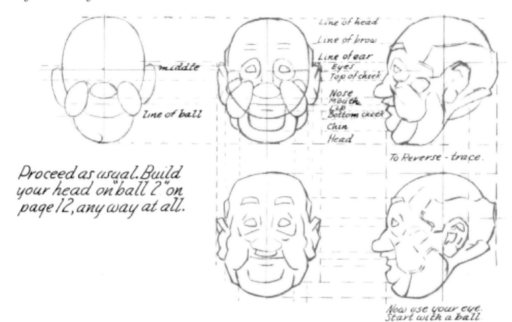

middle

Line of ball

Line of head
Line of brow
Line of ear
Eyes
Top of cheek
Nose
Mouth
Lip
Bottom cheek
Chin
Head

To Reverse - trace.

Proceed as usual. Build your head on "ball 2" on page 12, any way at all.

Now use your eye. Start with a ball

You first figure out a front view of your head. Then by measuring lines carried horizontally across, build a profile. Make the features and pieces all fit on the corresponding lines. When you have the "form," front and side, you can turn or tilt the ball and "draw by eye."

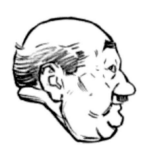

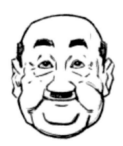

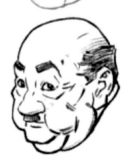

VARIETY BY DISTORTION

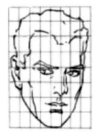

Take any head. You can distort it by the following methods. This is valuable in caricature. You can trace a photo, and draw from the tracing, or take any of your own drawings and distort them.

Square off the drawing or tracing as shown. Change the proportion. Fill in squares.

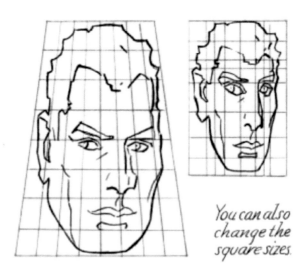

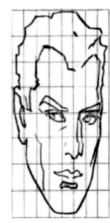

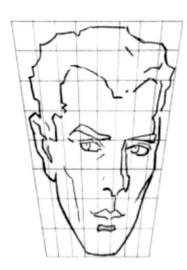

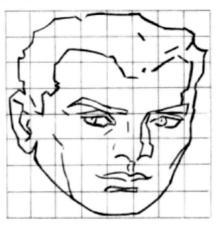

You can also change the square sizes.

Here again is a chance for your own invention. Draw a square around your subject. Divide each way into eight or more parts. If you wish to distort separate features, change the size of the squares into which they fall. Make the line cut through each square as it does in your copy, but changed to fit the new proportion of your squares. 1/2, 1/3 square, etc.

BABIES

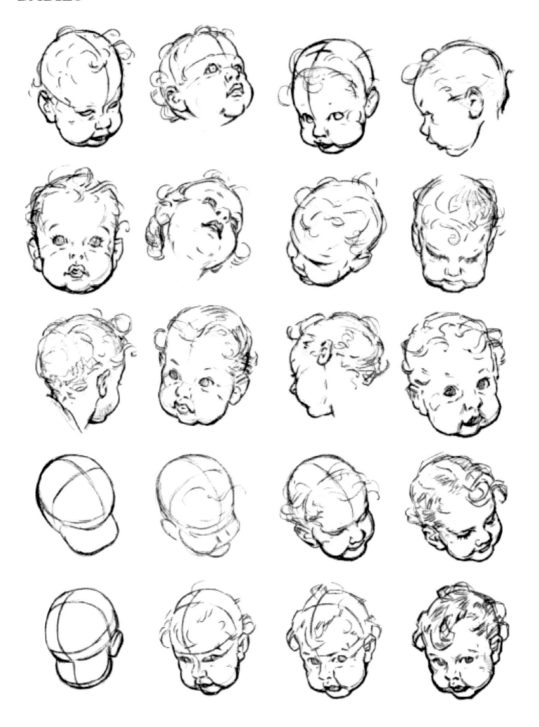

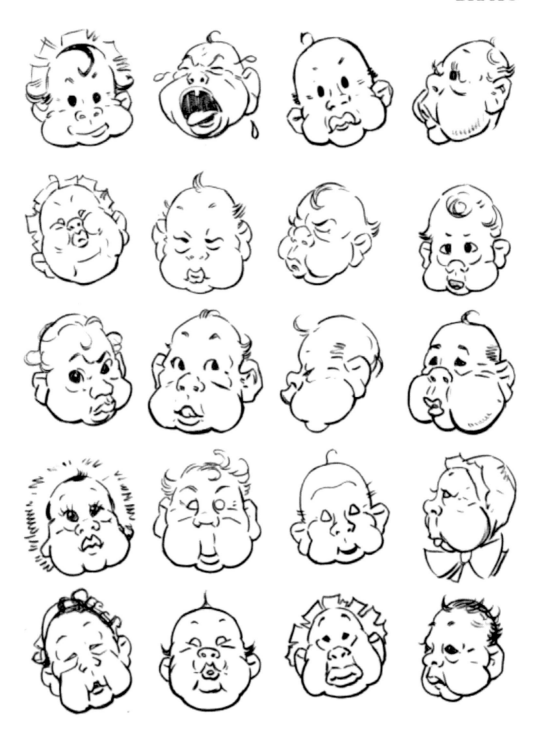

THE DIVIDED BALL AND PLANE METHOD

The Method Developed by Andrew Loomis, Which Makes Construction Simple for Any Type of Head.

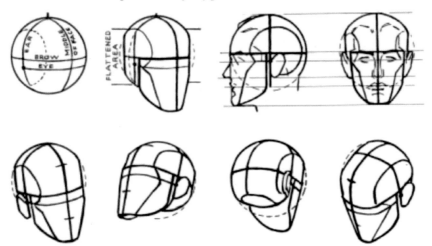

We go now into the most important section of the book. The method here worked out is a development of the simple groundwork you have already accomplished. It need not frighten you, since it is but slightly more complex than the work up to this point.

The cranium, as you perhaps have realized, is never a perfect ball in shape. To draw it correctly we must make alterations, some slight and others quite exaggerated, to fit the various types of skull. Nevertheless, we can take as a basic form a ball sliced off at the sides, leaving it a little wider one way than the other, and adding to it or taking some away. The forehead may be flattened, cut down, or built up as the case may be. The cranium may be elongated, widened, or narrowed. The facial plane may also be altered as we see fit without destroying our working principle. The plane simply attaches to the ball wherever we want it, which makes our method entirely flexible, so that we can represent *any type of head we choose.* All other methods I have yet seen do not start with a form anything like the skull, or make any allowance for the variety of shapes.

After this book was published, I learned with interest that a similar basic head form has been used for years by Miss E. Grace Hanks of the Pratt Institute, Brooklyn, and that she has written a book based on this method.

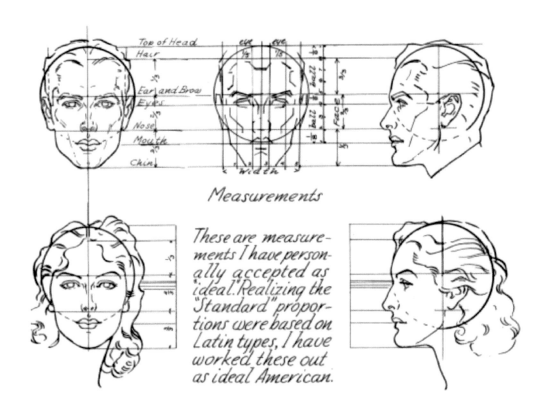

Measurements

These are measure-
ments I have person-
ally accepted as
"ideal." Realizing the
"Standard" propor-
tions were based on
Latin types, I have
worked these out
as ideal American.

The Divided Ball and Plane Method
has all these proportions worked
out in the ball and plane itself and
will automatically go into the head
unless the ball or plane is changed.
Unless the reader is seriously inclin-
ed to draw the head in realistic pro-
portion, it is advised to forgo serious
study of the measurements, depend-
ing merely upon the eye and the ball.

THE DIVIDED BALL AND PLANE METHOD

It is this flexibility and freedom built into the method that should make it of certain value. On page 37 I have given a set of measurements I consider ideal, but these need not be adhered to. To me the real value of the method is that it makes possible the accurate construction of the head without copy or model or, when a model is used, that it allows you to render the type recognizably and with certainty. It possesses powers of exaggeration for comic drawing and caricature as well as of serious interpretation. It opens an avenue of approach to the novice, dispenses to a large extent with the necessity for tedious and prolonged study, and gives almost at the outset the much needed quality of solidity which usually comes only with a knowledge of bone and muscle structure.

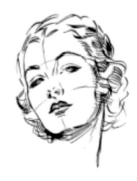

If you glance at page 39, it will be evident how the ball and plane is designed to give that appearance of actual bony structure. The skull lies within this basic form. But over and above this in importance is the helpful guidance it gives in placing the features in their correct positions, in relation to the pose of the head. This will come very quickly, and soon the eye will detect anything obviously "out of drawing."

Many years ago I sensed the lack of any method of approach having any marked degree of accuracy. I was told to draw the head as an egg or oval, and to proceed from there. Fine for a straight front view. But what of the jaw in a profile? There is but a slight hint of the skull formation in an egg shape alone. Again, I was told to build the head starting with a cube. While this aided one in sensing the perspective, it gave no hint of the skull. How much of the cube was to be cut away? Since then I have heard of "shadow methods" and others, yet in every case a previous knowledge of the head was necessary.

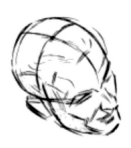

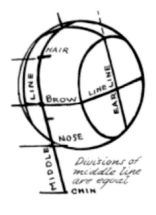

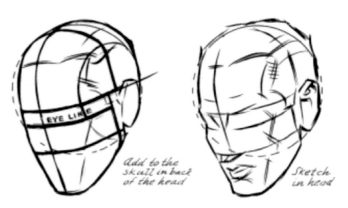

Divisions of
middle line
are equal

Add to the
skull in back
of the head

Sketch
in head

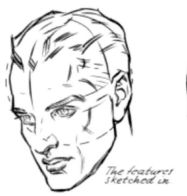

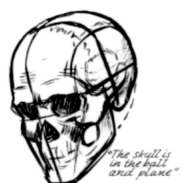

The plane may be raised
or lowered on the ball.
You can do anything you
wish with it. See Page
41 for application.

The features
sketched in.

"The skull is
in the ball
and plane"

How To Set up the Ball and Plane

Draw the ball as before, but now we drop the
middle line down off the ball. Divide middle line
into four parts that appear equal, each part
being equal to half the distance from "Browline" to
top of ball. Slice off sides by dropping earline
straight down. Middle line and earline are
parallel. The eyeline now drops below the
"equator," which is now the "Browline." Estab-
lish "Nose line" in middle of plane to run around
to ear. Ear fastens on at intersection of eye and
ear lines. Plane stops just short of ear. Top
of ear touches Browline. The skull protrudes
slightly from ball at back of head. It's easy.

THE DIVIDED BALL AND PLANE METHOD

What I wanted was a method whereby, if a head looked wrong, I could find out what was wrong with it, Tampering with a painted head to correct some bad construction or drawing usually ruined the work done. The necessity of starting the head correctly in the first place was obvious, so that the finishing could be approached with the confidence that after hours of work it would not go *"sour."* With closing dates of publications imminent, it is risky business to proceed without a full knowledge of what you are doing.

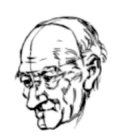

So this method evolved from personal necessity. I might state here that in the beginning I had not the slightest intention of putting it in book form. However, when the plan did work itself out finally, I was struck with its simplicity. It was one of those instances that make you wonder why you or somebody else had not thought of it before. The fact that it tied up with our first childish scribbles, which after all are a crude statement of form unhampered by superficial detail, only increased my enthusiasm. Why, then, could not such a plan be made available to all, from the child scribbler to the professional artist? The plan changes but slightly from the first round ball and added forms to the professional piece of work, the difference lying in the ability of the individual. It all hinges on the proper building of the ball and its divisions. Approached with the understanding that one is drawing solids instead of lines, the method becomes surprisingly simple.

I do not doubt but that these few pages will prove of inestimable value to many practicing artists, who I know have been confronted with the same difficulties of bad drawing and closing dates. But primarily the book is for John Jones, who always wanted to draw but could not.

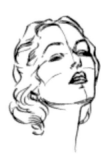

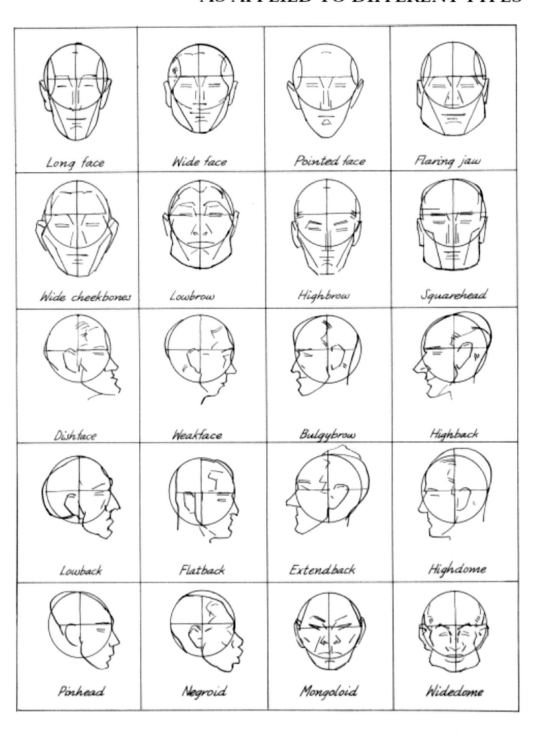

Long face	Wide face	Pointed face	Flaring jaw
Wide cheekbones	Lowbrow	Highbrow	Squarehead
Dishface	Weakface	Bulgybrow	Highback
Lowback	Flatback	Extendback	Highdome
Pinhead	Negroid	Mongoloid	Widedome

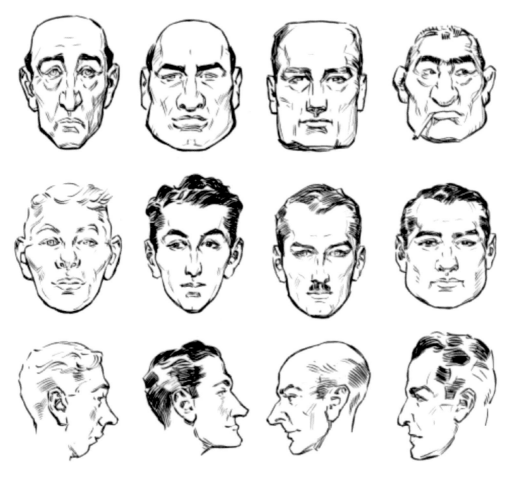

To test your "Eye for form", see how many of the heads you can classify.(Page 41).

SOME HEADS BASED ON PAGE 41

This page must give you some idea of the unlimited variety of types and characters possible through building by the Divided Ball and Plane method. There are thousands of types, and each looks different mostly because of the skull rather than the features. It's fun to study an individual, and try to figure out what kind of ball and plane go together to make up his face. You really learn to look deep into character, and beneath the surface. This method calls for no clairvoyance, but a quick eye and a skillful hand.

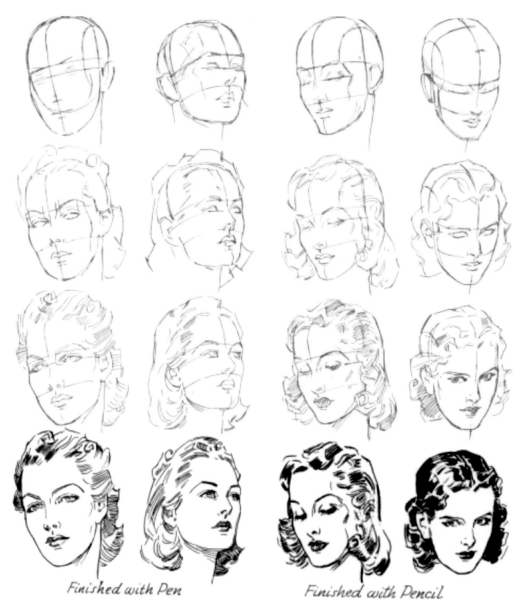

Finished with Pen Finished with Pencil

THE PRETTY GIRL

A pleasing head of a girl depends ninety-nine percent on how well
you draw it. More exactly, the ball must be drawn well, the con-
struction lines correctly placed on the ball and plane, and the fea-
tures nicely placed. Remember there is the width of an eye be-
tween the eyes. Do not place the mouth too low or get the nose too
long. I have used a pen here. Try it sometimes.

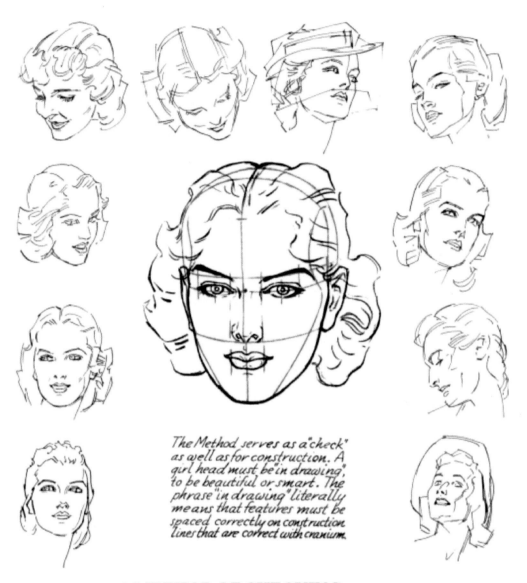

The Method serves as a "check" as well as for construction. A girl head must be "in drawing" to be beautiful or smart. The phrase "in drawing" literally means that features must be spaced correctly on construction lines that are correct with cranium.

A METHOD OF CHECKING

The blue lines in the diagram above are our same construction lines. They may be done on tracing paper over any face. You can thus quickly find a feature that has been incorrectly placed. You can also "find" the ball and plane position in a photographic head this way. Whether you are building or tearing down, the method applies.

THE WOMEN FOLKS

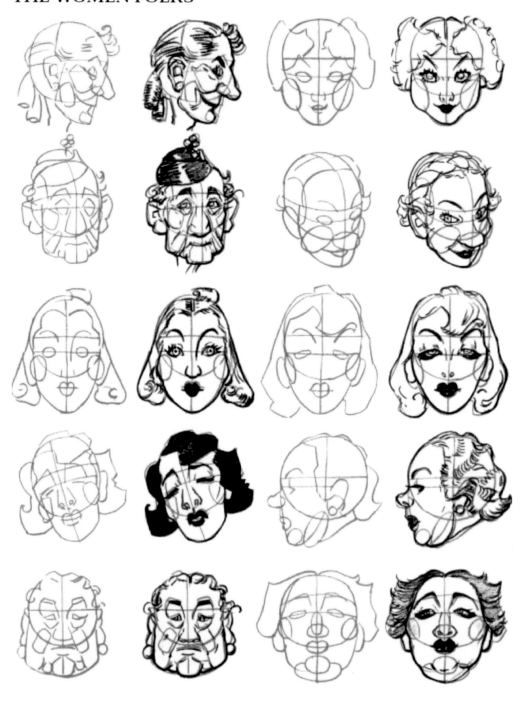

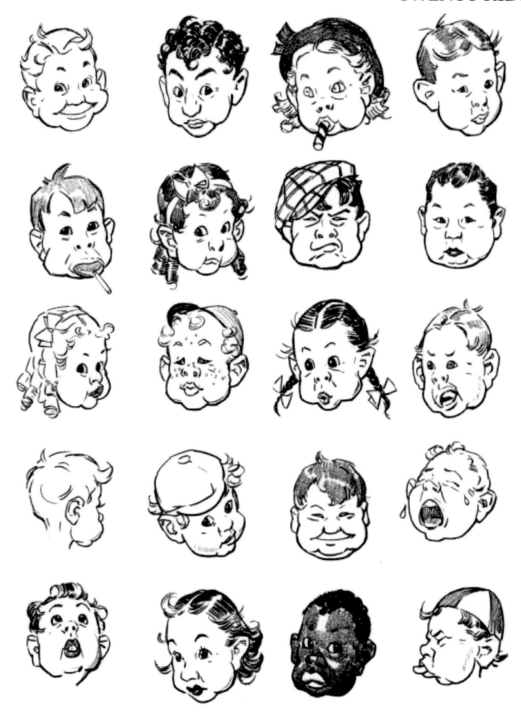

ETERNAL YOUTH

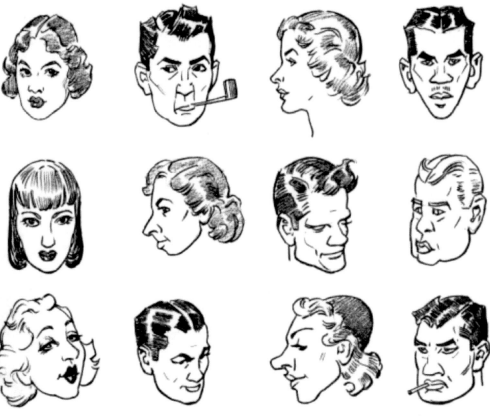

You should now be able to construct and finish these.

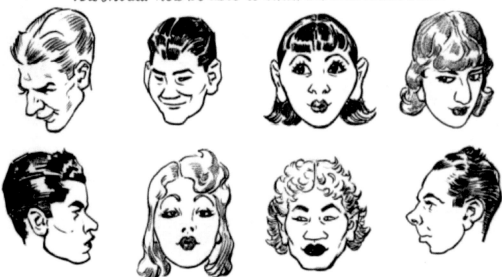

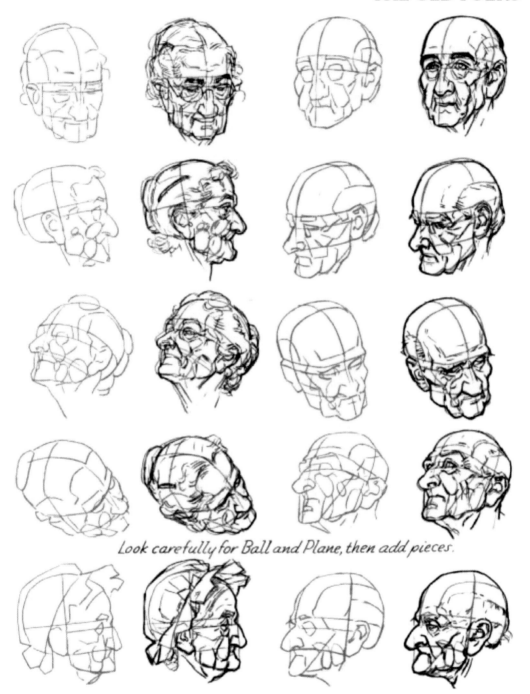

Look carefully for Ball and Plane, then add pieces.

THE COMIC FIGURE

You know, I've a hunch you have been itching to get into this portion of the book. Well, it is really going to be great fun to create little people of your own, doing anything you want them to. There is nothing hidebound in this plan either. Take it in easy doses for the fun that's in it. Whether the folks you draw will ever bring home the bacon is a matter of circumstance and how clever you get to be. But it's worth the effort to get that bang out of being able to do it.

When you were a very little boy or girl your brain children probably looked like these. If they did, you had a great deal of undeveloped talent, and if you have not been drawing ever since, it's a real shame. When the little youngster starts to draw, he instinctively does a better job than he does later on. He goes to essentials, a crude representation of the bulk without the detail. Soon he forgets the body and starts drawing buttons and clothes with a face on them. Result: he gets discouraged and transfers his attention to some pretty blond curls or a new bicycle.

In all seriousness, I say that Nos. 1 and 2 of the marginal drawings have great possibilities; 3 and 4 still have hope. But 5 verges on those awful drawings in public places.

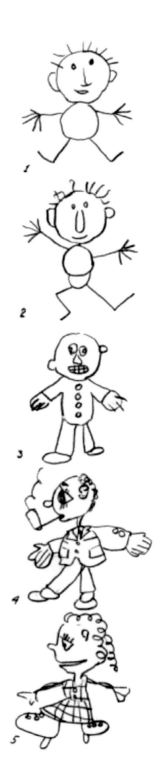

As he was

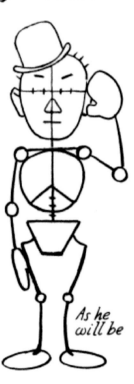

As he will be

Now we start with something very much like 1 and 2. For want of a better name we shall call him "Doohinkus." All we need do is add some sort of box for a pelvis, some pads for hands and feet, some balls at the joints, and a straight line across for shoulders. We thus give him the following characteristics.

Head is a ball.

Chest is a ball.

Pelvis is a box slanted out at back and in at the sides.

The spine does not go through the chest ball but around the back of it.

The legs are not straight but curve in to the knees and out toward the foot.

Forearm is slightly curved.

Chest ball is divided by a line through the middle and flaring lines at the bottom, like a Y upside down.

The reason for the curve on the bones is that they thus become "springy" and shock-absorbing.

Without those curves we would be nervous wrecks before we were in short pants or panties as the case may be.

Every limb is movable in practically all directions.

The chest ball is fixed to the spine but the spine bends in all directions. It can also twist or turn, so that there is a wide range of movements possible between spine and pelvis.

The human body is just about the nicest bit of mechanics we have in the world. We can walk, run, jump, climb, stand erect, sit, all without any oiling or burnt-out sparkplugs. Our motor starts and stops once. If we take care of the engine it will outlast any metal one. Let's go!

HERE WE GO!

The proportions of your little figures may be varied in any sort of way. Below we show a variety of comic exaggerations.

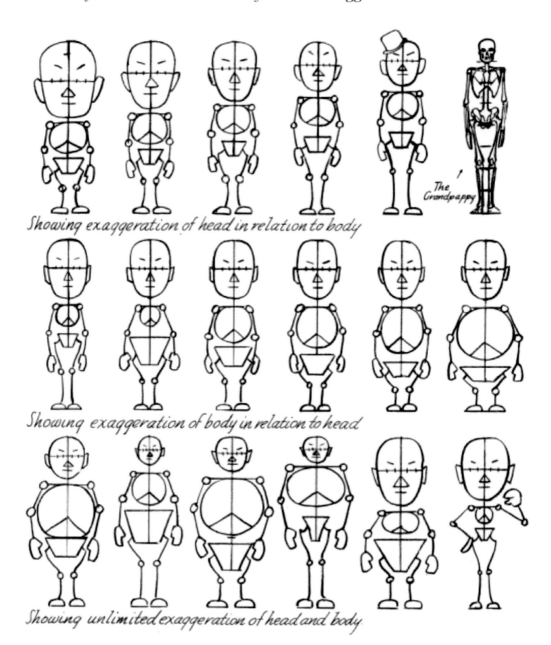

Showing exaggeration of head in relation to body

Showing exaggeration of body in relation to head

Showing unlimited exaggeration of head and body

WE START ON THE FIGURE

We shall start at once to put them into action. There will always be movement of the parts. Draw this page carefully and become thoroughly familiar with the movement of each part.

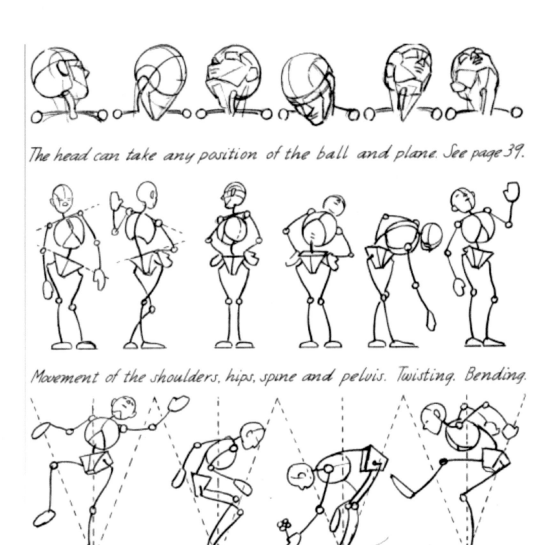

The head can take any position of the ball and plane. See page 39.

Movement of the shoulders, hips, spine and pelvis. Twisting. Bending.

The weight of the body must be evenly distributed over a central point of gravity. This is equilibrium. Just a couple and it's gone, eh what.

DOOHINKUS MOVES ABOUT. STUDY THE FRAMEWORK

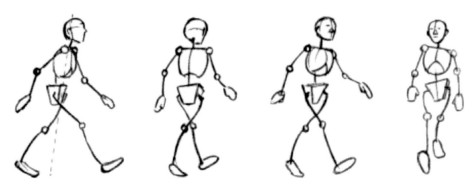

In walking, the arms move in reverse motion of the legs. Example, left foot forward, left arm back. The weight is tipped forward, catching balance with each step. Try some of these.

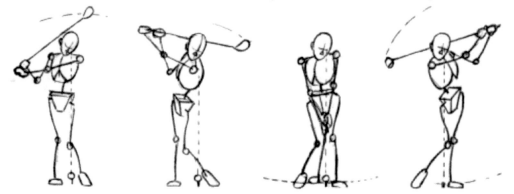

A continuity of action. I purposely picked a tough one, and probably will get my neck out.

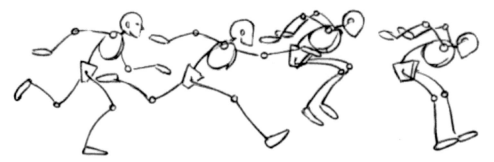

In running, the arms also move in reverse of the legs. In jumping the arms and legs move in unison, legs forward, arms back. Then the arms swing down in landing.

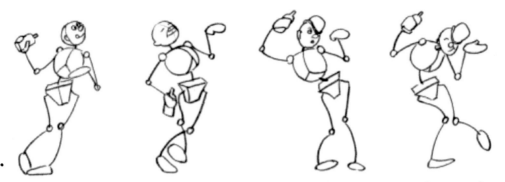

Now, folks, just to get you acquainted with the actions of Doohinkus, I present here a little drama entitled, "He met up with Gas House Nellie, much to his chagrin."

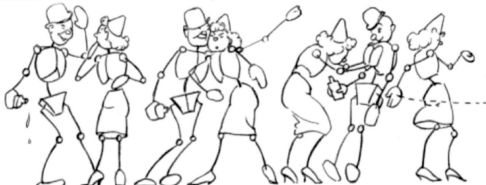

"Howdy, Toots," Doohinkus said. "Mind if I come in?" And he placed his arm about her.

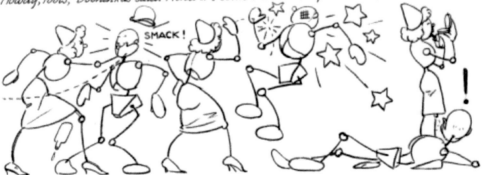

She daintily withdrew, but on the air there came a smack, as lovers oft' will do. (Curtain). Moral - Whatever you do with a bottle and a maiden, dont do it.

DO SOME OF THESE

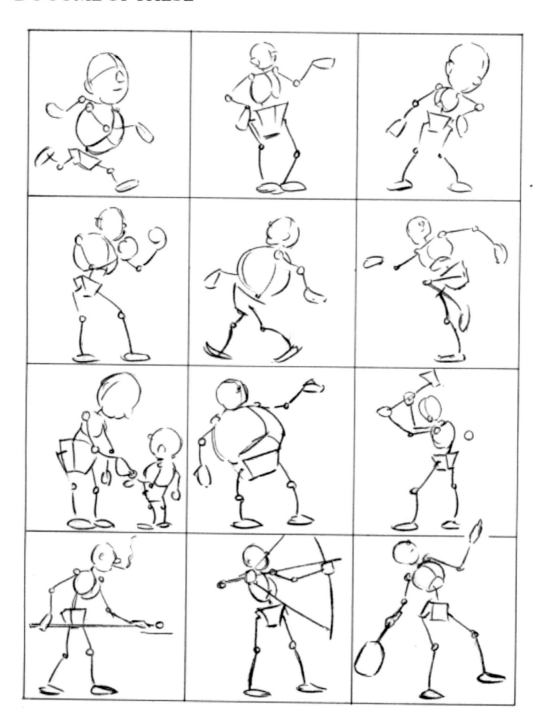

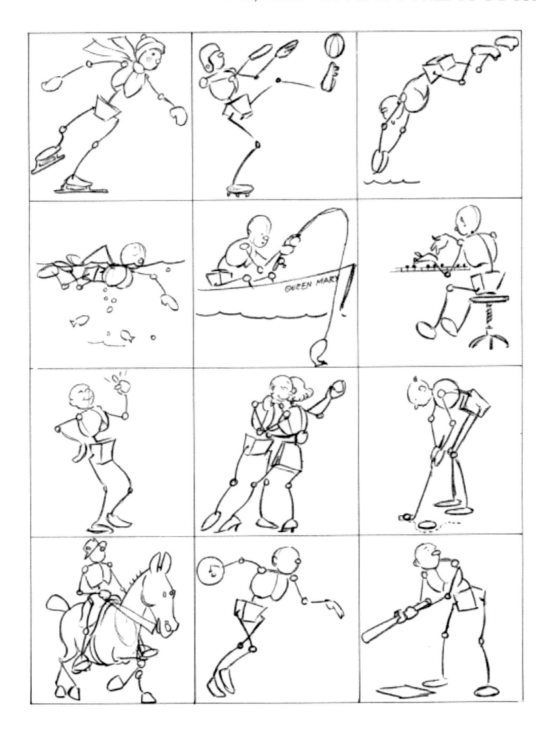

BUILDING ON THE FRAMEWORK

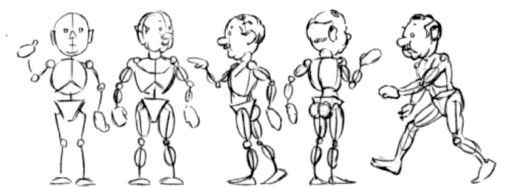

It's a simple matter, now, to add the "meat balls" between the joints. Then just draw lines around enclosing the forms. This is drawing "from the inside out".

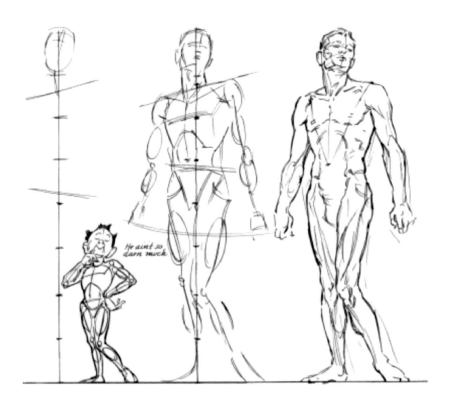

He aint so darn much

Showing how much like the seriously drawn figure the little fellow really is.

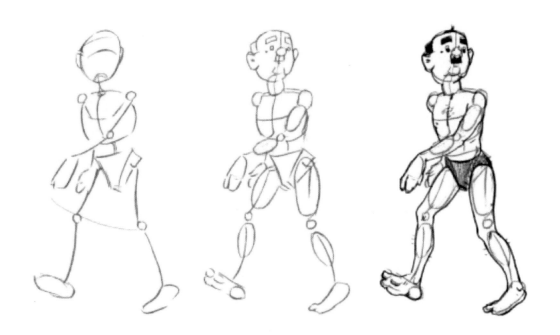

It's going to be real fun creating little frames, then building up the figures.

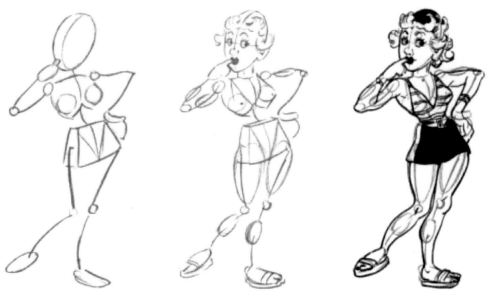

Note, for girls we turn the pelvis block over. Now we'll let the camera help us.

A WAY TO SET UP THE ACTION

Take any jointed doll if possible, one jointed at the waist. This fellow was a plain wooden art-store man-nikin. In order to make him exist for you as some-thing more than wooden chunks, I dolled him up, with paint, putty, and a bit of hair from the bathroom rug. Then I got busy with my candid camera. He is a queer-looking little guy, a sort of cross between Groucho Marx and a cigar-store Indian; but he is made of parts, and it is the appearance of these parts in action that we are interested in. In this way Doohinkus Manni-kin is better than a live model. The black lines on him help you his bulk, just as they do on the ball.

Take some of these poses. Start by drawing the frame-work in the approximate action. It is not important that you maintain the same proportions, and you can substitute any head. Change him to suit yourself, but watch the positions of the parts carefully. Build on each part as you it. Note whether lines at joints curve up or down, how the part is tipped toward or away from you, you can exaggerate the action of the hips and shoulders, as those actions were quite limited in the mannikin. You can also, if you wish, render the light and shadow on the parts.

Tracing these, or copying without building, will do you no good. But if you will "build" a dozen or so, you will be able to set up figures of your own, in al-most any action. The correct assembling of the parts of the figure is much more important than actual knowledge of the bones and muscles. You cannot put clothes on your figures properly without knowing the action of under the clothes, and the flexing and pull-ing of the material over them from one part to an-other.

Pages 66 and 67 will show how to go about it.

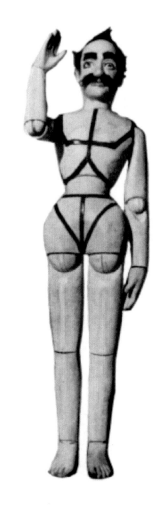

HIS IMPERIAL MAJESTY
DOOHINKUS
MANNIKIN
(without his underwear)

DOOHINKUS MANNIKIN SHOWS YOU THE PARTS IN ACTION

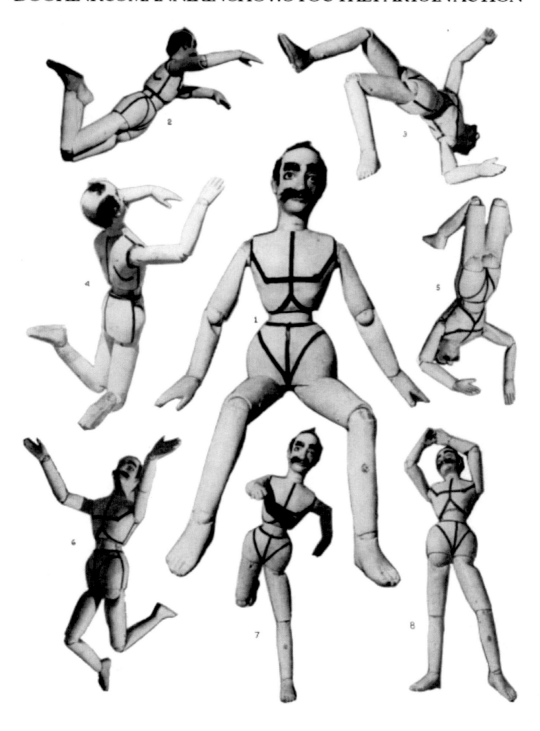

BUILD FIGURES FROM THESE
START WITH THE FRAMEWORK

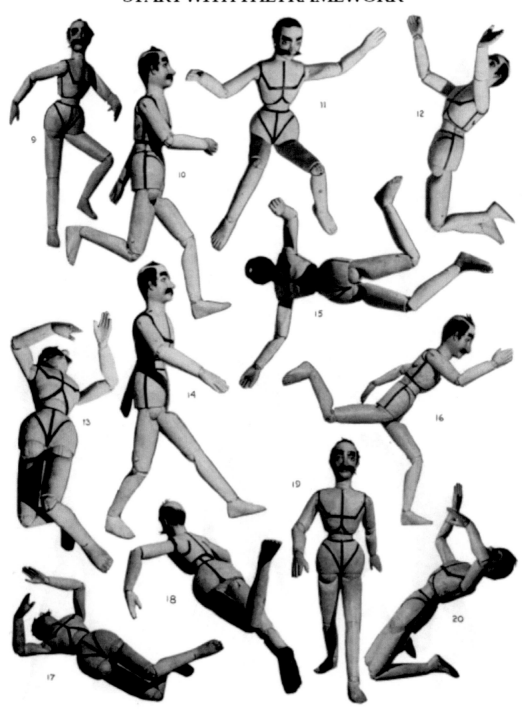

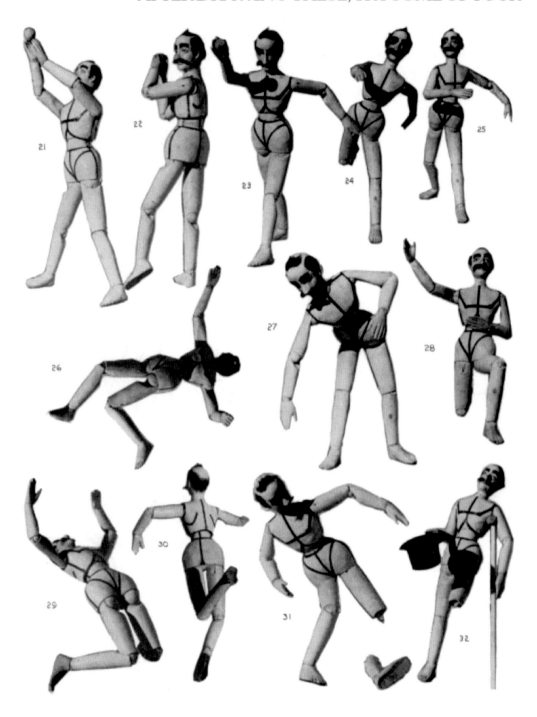

HOW YOU USE THE DOOHINKUS POSES

Here is the way to go about the preceding poses. I have chosen figure No. 8 at random. First, it is a good idea to know what the normal figure is like. You needn't draw this unless you are interested. The bottom figures illustrate how the exaggerated is based on the normal.

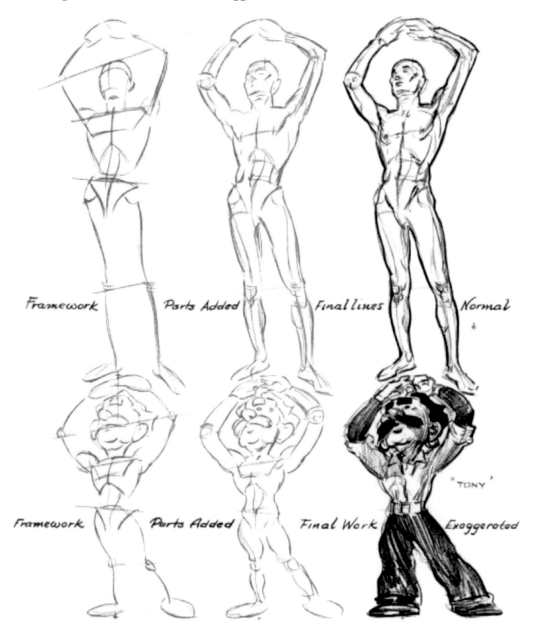

Framework Parts Added Final lines Normal

Framework Parts Added Final Work Exaggerated

"TONY"

JUST PLAY WITH THE FIGURES

The main idea is to enjoy yourself. Some day you may just put clothes right over the framework. But it is better always to sketch in the figure. Do not follow the photos literally. Do a lot of inventing, I wish I had more space here, but perhaps these will give you a working basis.

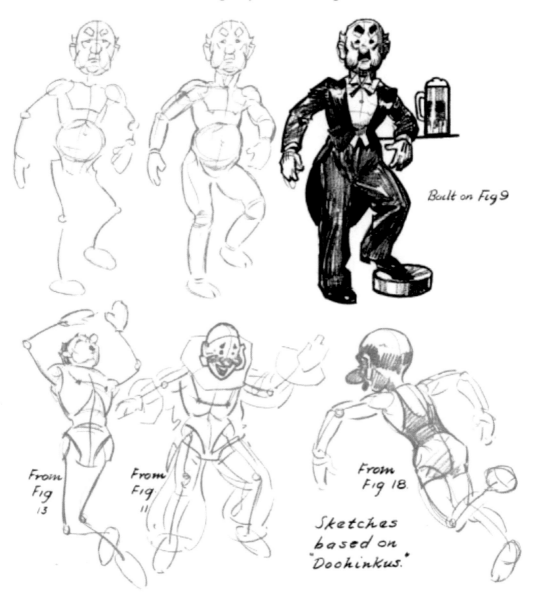

Built on Fig 9

From Fig 13

From Fig 11

From Fig 18.

Sketches based on "Doohinkus."

A ball, a square, and a triangle can be the foundation for a coat. In the side and ¾ veiw the ball is flattened at back and cut down in front. Trousers are not as

easy, but remember that folds radiate from joints and crinkle on opposite sides. You should study folds from life to understand them. Knees, elbows, hips and

The sleeve works about like the trousers with elbow like knee. But watch for more twist.

Buttons cause folds. Learn to draw them for they explain action of figure.

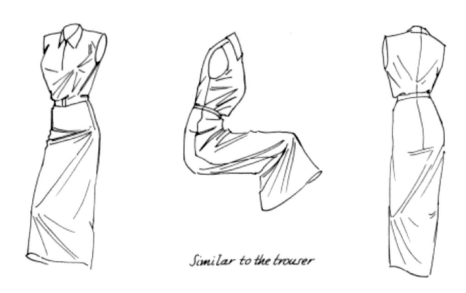

Similar to the trouser

The busts, hips, shoulders and knees are all important in the drape of women's clothes. Folds radiate from these. There are excellent books on "Fashion Drawing".

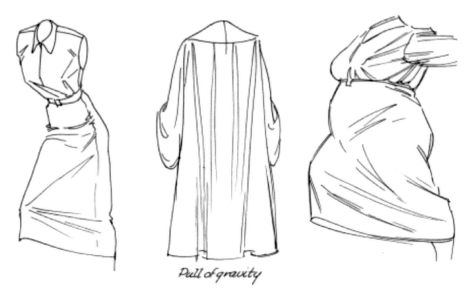

Pull of gravity

Clothing varies but the principle remains. Clothing must tell the story of the figure.

HOW TO DRAW A HAT CORRECTLY

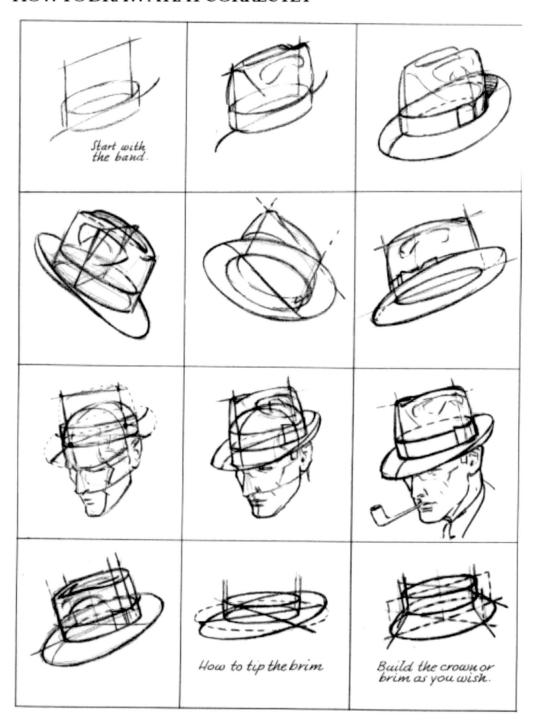

Start with the band.

How to tip the brim

Build the crown or brim as you wish.

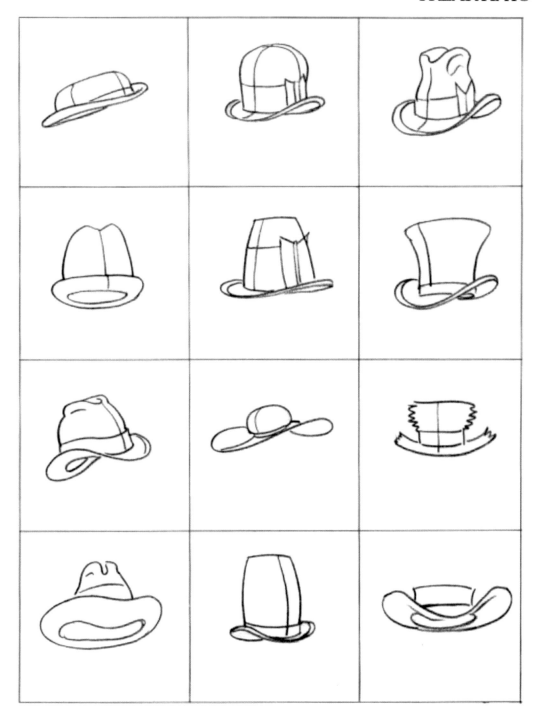

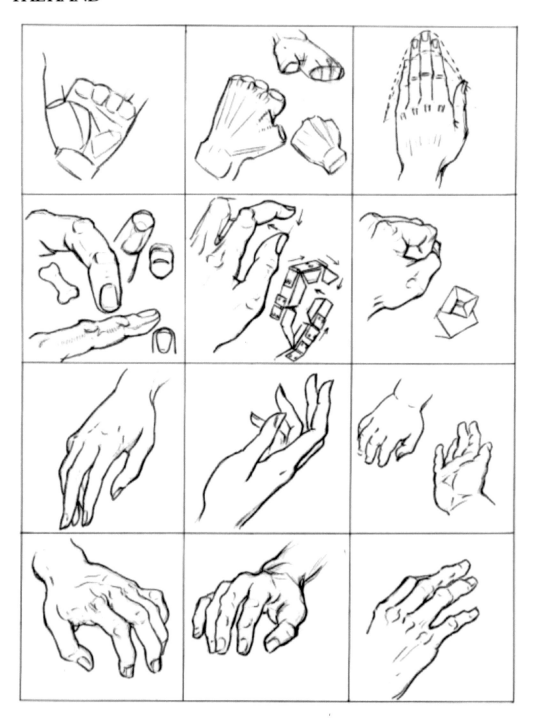

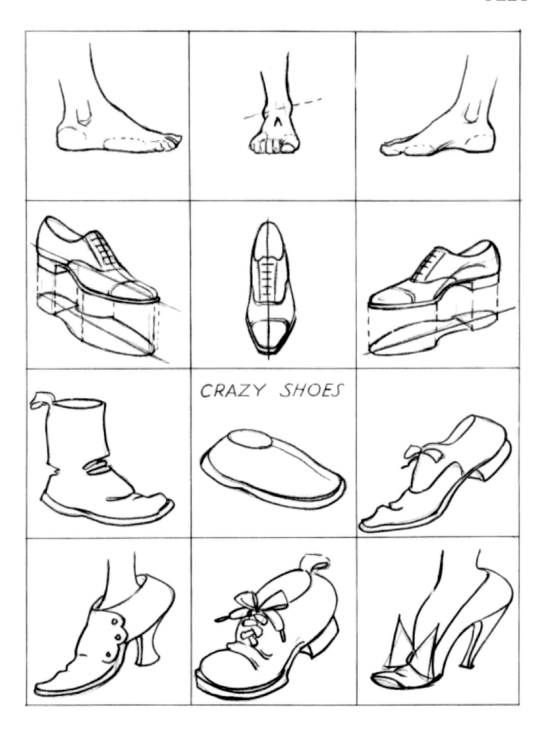

CRAZY SHOES

NOW WE BUILD THE FIGURE AND PUT ON SOME CLOTHES

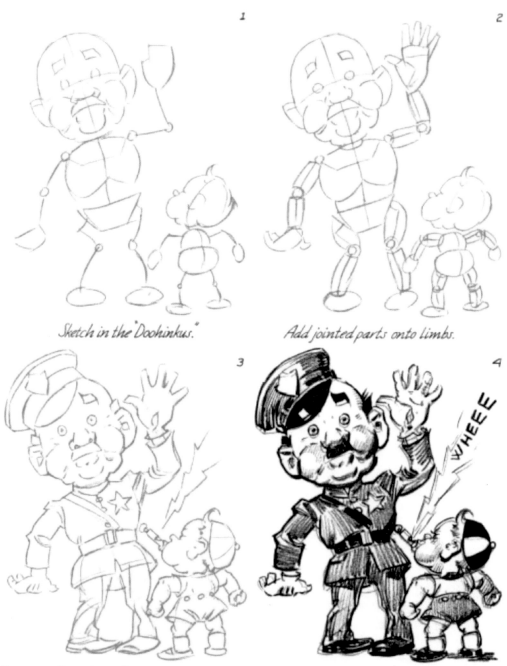

1 Sketch in the "Doohinkus."

2 Add jointed parts onto limbs.

3

4 WHEEE

Erase superfluous lines. Sketch in clothes lightly. Finish by drawing in final heavy lines as you wish.

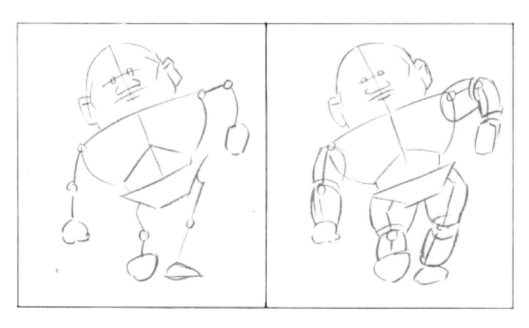

Build the frame work in. Build on the jointed parts.

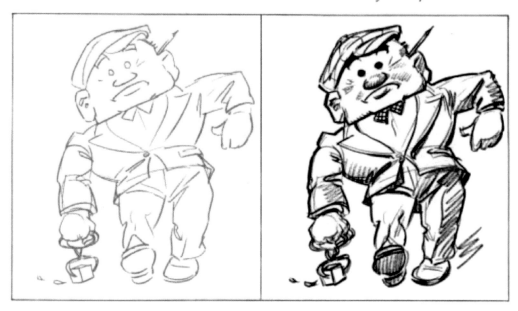

Sketch on clothes after erasing construction. Finish as you wish. Now honestly isn't it simple?

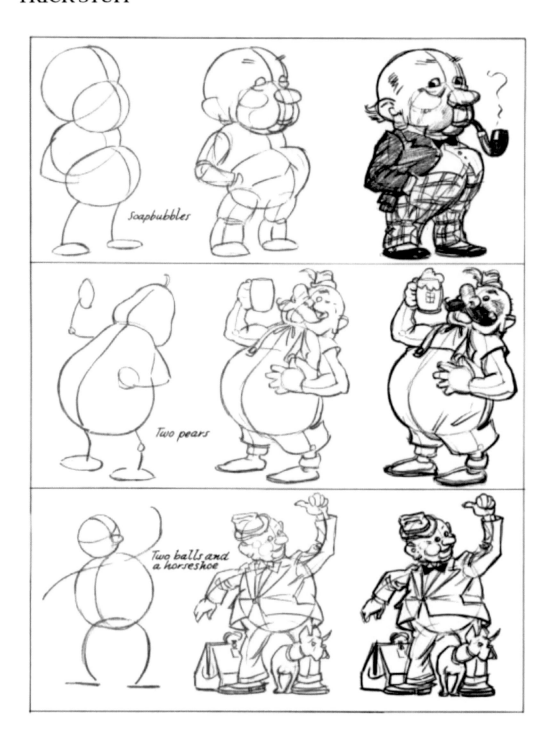

Soapbubbles

Two pears

Two balls and
a horseshoe

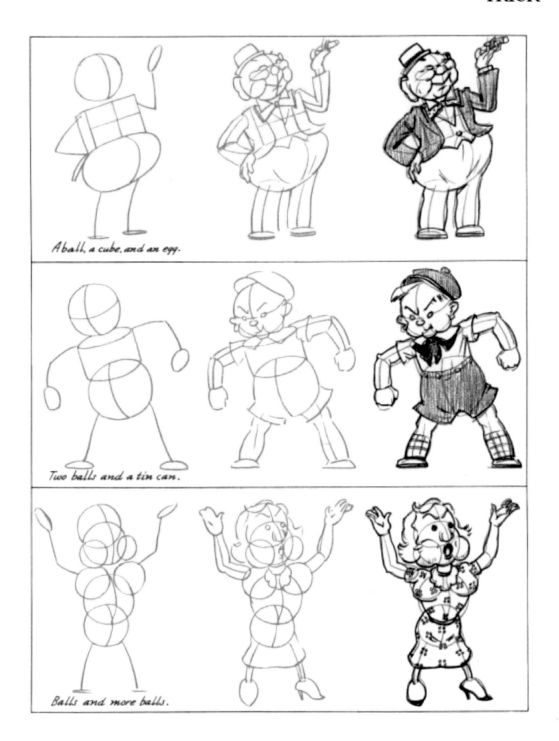

A ball, a cube, and an egg.

Two balls and a tin can.

Balls and more balls.

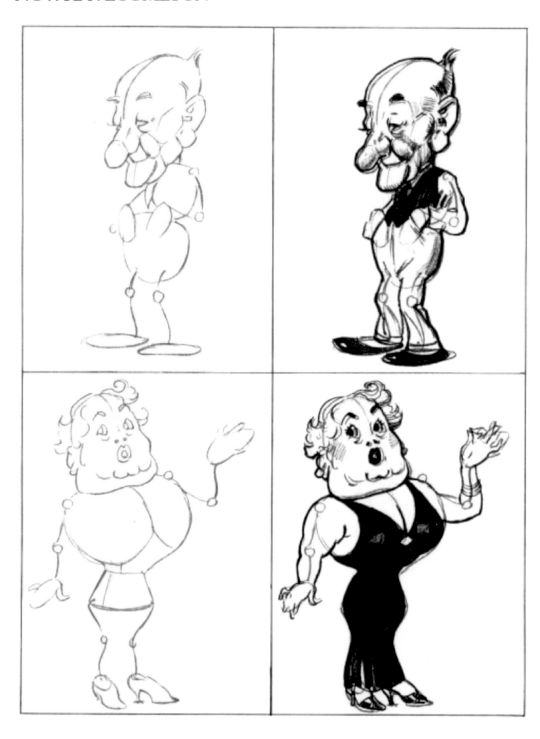

TRY TO WORK OUT THE CONSTRUCTION YOURSELF

EXPERIMENT WITH THESE

THESE OUGHT TO BE INTERESTING

NOW LET'S MIX UP THE RACES

YOU CAN DRAW THEM ALL BY OUR METHODS

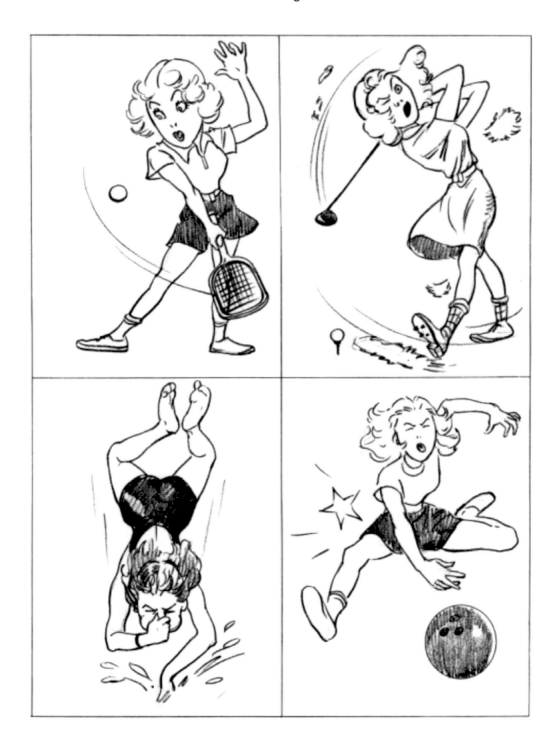

VAMPS

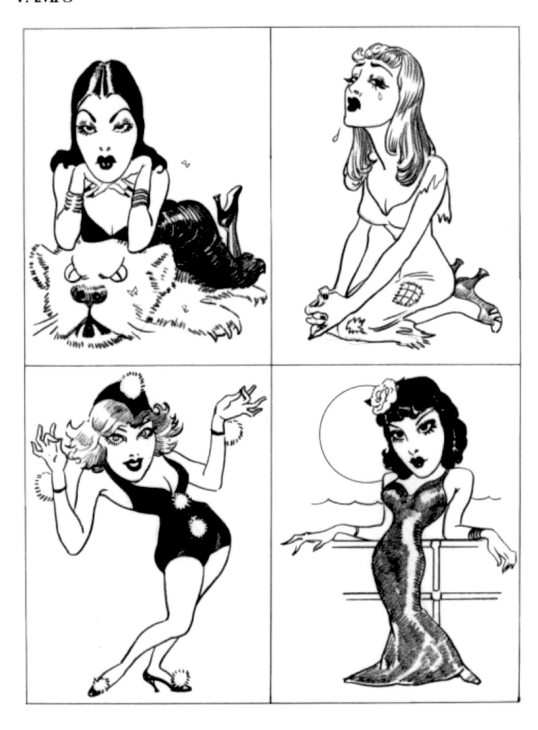

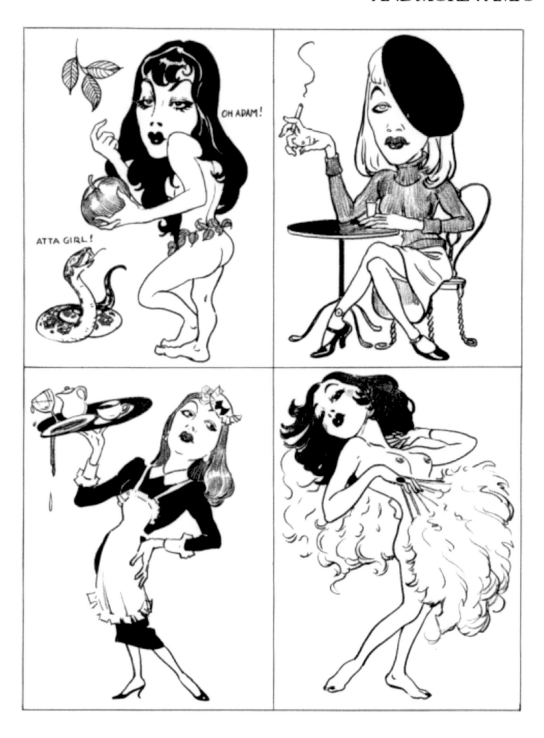

FORESHORTENING

Unless one has a sound method of building, foreshortening is very difficult. In the figure at the right, the parts resemble the Doohinkus photos. If you think of the figure as sections fitted together, foreshortening takes

fully as we built the head in Part One. Think of solids

Below, we obtain foreshortening by projecting a profile into a front view, or the reverse, as we did with the head. Establish the desired tilt and position of the parts, then by parallel lines build the other position of the figure so that all important points coincide. When the figure is close, increase the parts that are closest and diminish the parts that are away from you. I did not do this, fearing it might confuse you. I personally prefer the method at the top, using the eye, but often a difficult problem can be worked out easily this way, and it is well to know how.

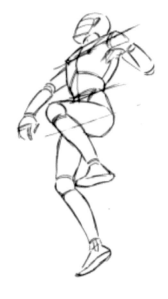

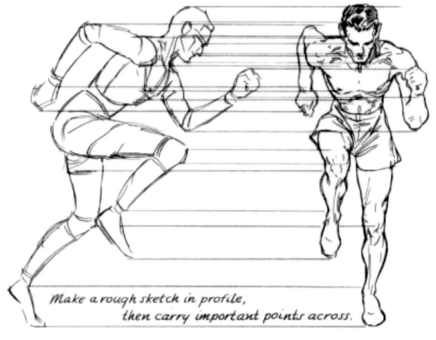

Make a rough sketch in profile, then carry important points across.

THUS ENDETH PART TWO

(From Page 57)

Here's Gas House Nellie back with us, and what a wallop! She's here to show you there's no foolin' about those little Doohinkuses, You can get more real stuff into your figures in two minutes this way than in two days of trying to horse around with the finished drawing that has not been planned out. If Nellie isn't really slamming this guy, I'm a Chinaman. I can almost hear it.

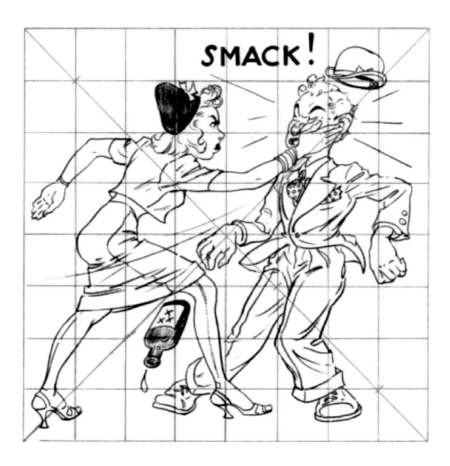

NOW THAT I'VE GOT ALL OF YOU, WHAT TO DO!

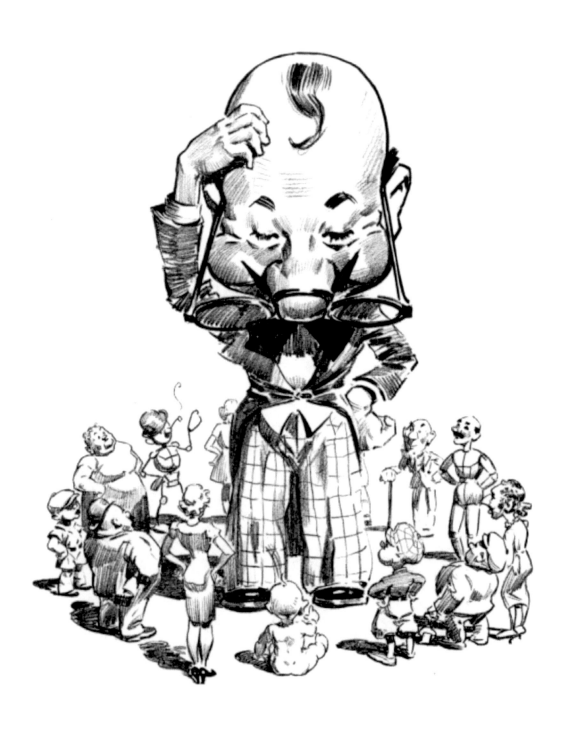

PART THREE A WORLD FOR YOUR FIGURES TO LIVE IN

PERSPECTIVE

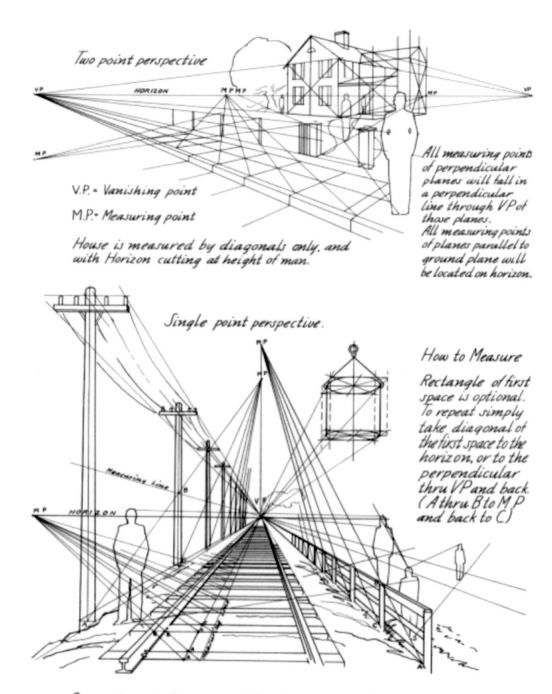

Two point perspective

V.P. = Vanishing point

M.P. = Measuring point

House is measured by diagonals only, and with Horizon cutting at height of man.

All measuring points of perpendicular planes will fall in a perpendicular line through VP of those planes.
All measuring points of planes parallel to ground plane will be located on horizon.

Single point perspective.

How to Measure

Rectangle of first space is optional. To repeat simply take diagonal of the first space to the horizon, or to the perpendicular thru VP and back. (A thru B to MP and back to C)

Perspective looks more difficult than it is. You must know it to draw.

HOW TO ESTABLISH FIGURES ON THE GROUND

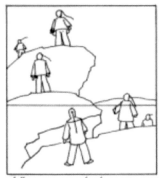

When ground plane is not level they may be above or below Horizon, but must be shown in true perspective.

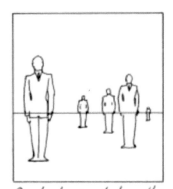

On a level ground plane the Horizon must cut through all figures of the same height in the same place.

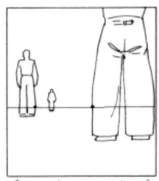

Always plan your picture for the closest figure, or he may not get in the picture.

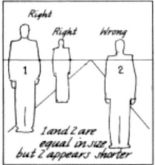

The horizon may be fixed at any height on the figure, but all figures must be related

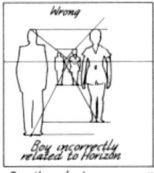

Boy, though drawn smaller actually is larger, because of disrelation to man and horizon.

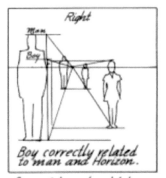

Size of boy should be approximated by comparison to man and set properly on ground plane.

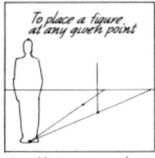

Establish points where figures are desired. Then draw line from feet thru points to horizon.

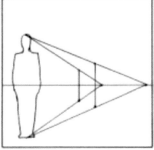

Then bring line back to point at top of figure. Erect perpendicular at the points chosen.

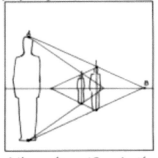

Where line AB cuts the perpendicular is the same relative height of original figure.

PERSPECTIVE IN THE FIGURE

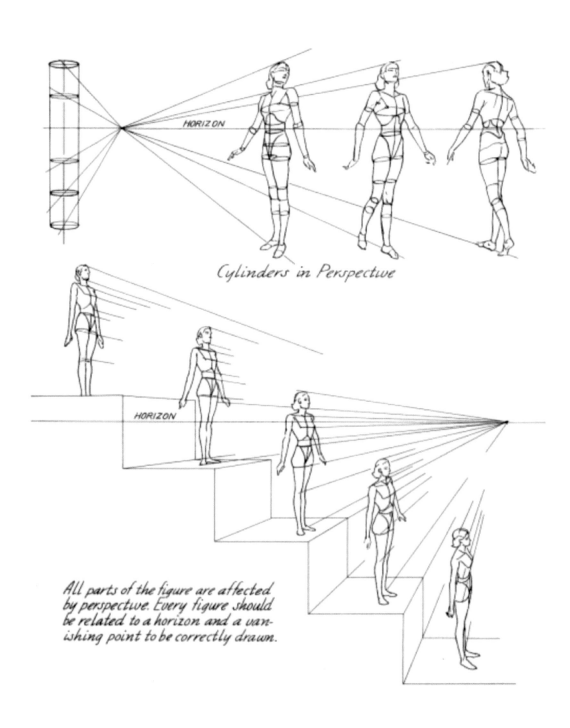

HORIZON

Cylinders in Perspective

HORIZON

All parts of the figure are affected
by perspective. Every figure should
be related to a horizon and a van-
ishing point to be correctly drawn.

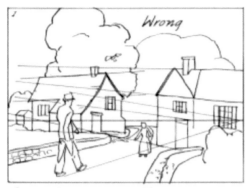

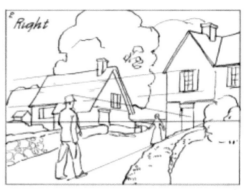

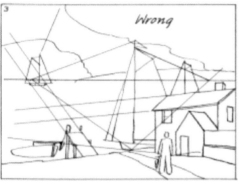

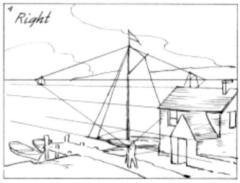

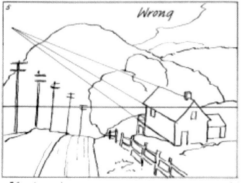

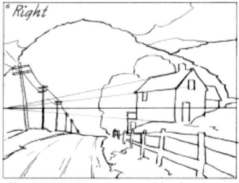

Study these pictures. These are common faults. In number one nothing is related.

Here the perspective and proportions of the houses are corrected to fit the figures.

All vanishing points must fall on the same horizon. The above fail to do this.

Corrected. Boats now relative in size. The figure had to be reduced. Much better!

If this house were correct we would see the distance over the mountain.

Horizon may be invisible, but it is always there, for it is your own eye level.

FURNITURE

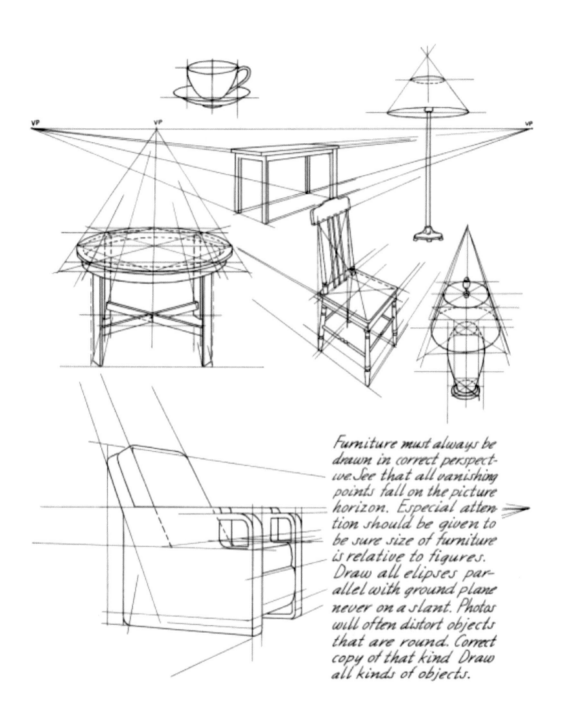

Furniture must always be
drawn in correct perspect-
we. See that all vanishing
points fall on the picture
horizon. Especial atten-
tion should be given to
be sure size of furniture
is relative to figures.
Draw all elipses par-
allel with ground plane
never on a slant. Photos
will often distort objects
that are round. Correct
copy of that kind Draw
all kinds of objects.

HOW TO PROJECT FURNITURE ONTO THE GROUND PLANE

Here is an excellent method for building furniture and figures on a ground plane. It is simpler

Draw a square or rectangle. Then square it off. Plan the size and positions of the furniture and figures. Establish a base line above your plan and a horizon above it. Carry the division up thru base line to the vanishing point. The depth of the first square is optional. (square 8) Establish measuring line by drawing diagonal thru square 8. Where it cuts other division lines, marks off the depths of the other squares. Number all squares and each line and point can be thus located. Now establish heights from any desired scale in manner described Page 99.

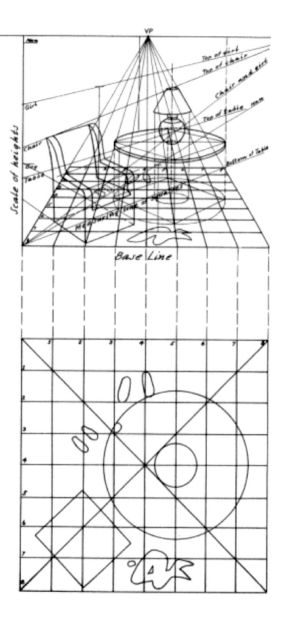

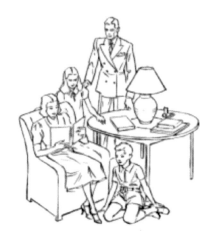

BUILDING AN INTERIOR FROM A GROUND PLAN-I

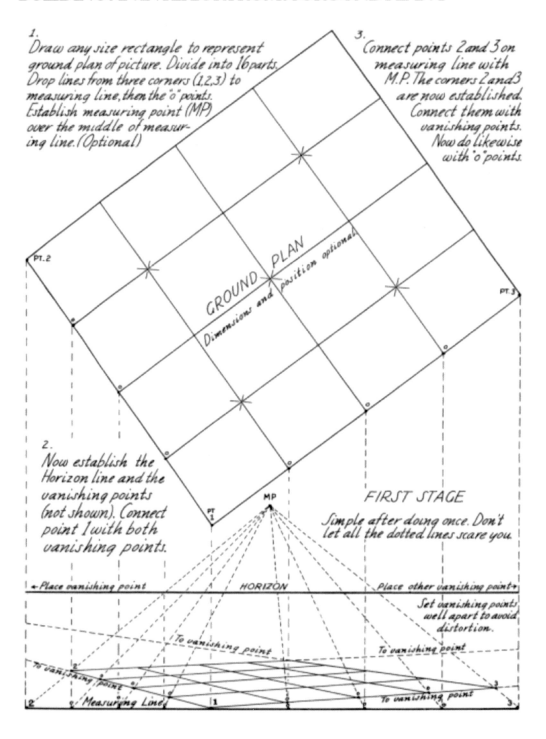

1.
Draw any size rectangle to represent ground plan of picture. Divide into 16 parts. Drop lines from three corners (1,2,3) to measuring line, then the "o" points. Establish measuring point (MP) over the middle of measuring line. (Optional)

3.
Connect points 2 and 3 on measuring line with M.P. The corners 2 and 3 are now established. Connect them with vanishing points. Now do likewise with "o" points.

GROUND PLAN
Dimensions and position optional

PT.2

PT.3

PT.1

MP

2.
Now establish the Horizon line and the vanishing points (not shown). Connect point 1 with both vanishing points.

FIRST STAGE

Simple after doing once. Don't let all the dotted lines scare you.

← Place vanishing point HORIZON Place other vanishing point →

Set vanishing points well apart to avoid distortion.

To vanishing point

To vanishing point

To vanishing point

To vanishing point

Measuring Line

BUILDING AN INTERIOR FROM A GROUND PLAN-II

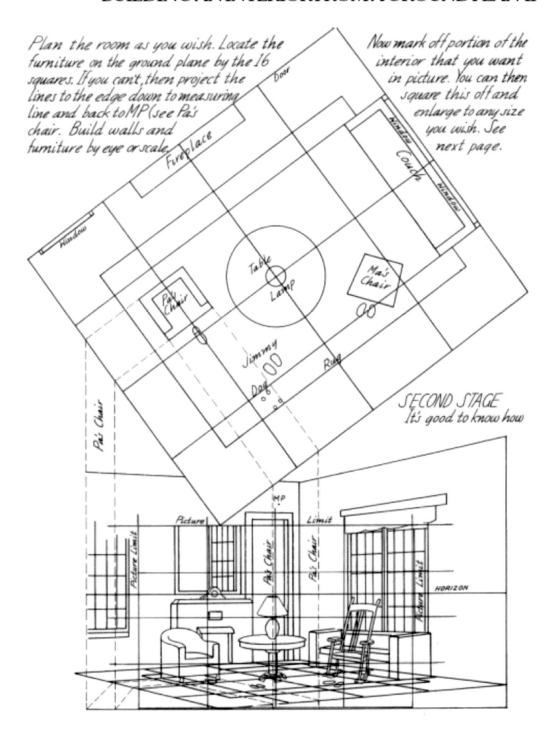

Plan the room as you wish. Locate the furniture on the ground plane by the 16 squares. If you can't, then project the lines to the edge down to measuring line and back to MP (see Pa's chair. Build walls and furniture by eye or scale.

Now mark off portion of the interior that you want in picture. You can then square this off and enlarge to any size you wish. See next page.

Door

Fireplace

Window

Window

Couch

Window

Table

Lamp

Ma's Chair

Pa's Chair

Pa's Chair

Jimmy

Dog

Rug

SECOND STAGE
It's good to know how

MP

Picture

Limit

Picture Limit

Pa's Chair

Pa's Chair

Picture Limit

HORIZON

BUILDING AN INTERIOR FROM A GROUND PLAN-III

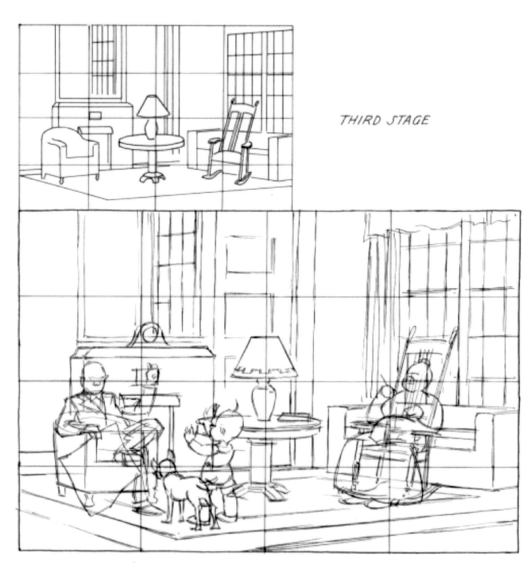

THIRD STAGE

Now take the little squared off perspective drawing and enlarge it by laying out larger rectangle in same proportions. It is best now to put away your rule and use your eye to fill in the larger squares. Ruled lines are stiff and are mechanical. When room is sketched in, sketch in the figures. If you wish you can make separate sketches for figures until you are satisfied they will tell the story. In this manner you can build any kind of picture.

BUILDING AN INTERIOR FROM A GROUND PLAN-IV

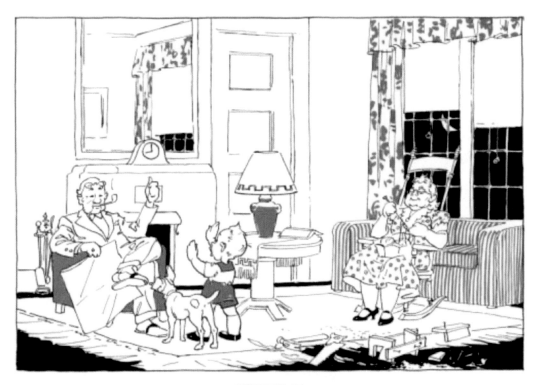

BEDTIME

And here is the finished drawing. It's fun to try inking in some of your pencil drawings. Get a bottle of waterproof black drawing ink. You can get a box of school water colors, also, and get still more fun out of it. Knowing just what is the correct perspective helps so much to give that solid, finished, and professional look. This procedure opens up a whole world for the little figures you have learned to draw. It is worth while to see what you can do with this method. It offers a possibility of setting some work, besides the thrill of doing it. Now we shall take up a new subject.

LIGHT AND SHADOW: THE PRINCIPLE

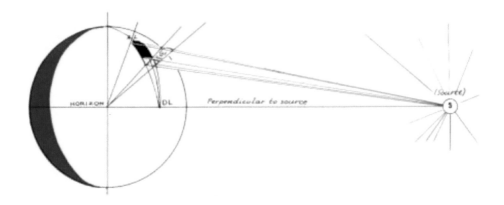

The Principle as in Space

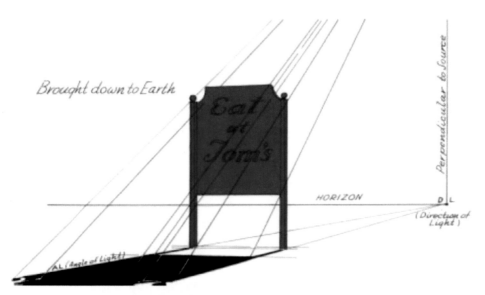

Brought down to Earth

Rays of light travel in straight lines. From any spot, the middle ray, the "perpendicular to source," would meet the earth and pass through its center. At the point directly under the source we establish the point DL, meaning "direction of light." S will mean "source" at the top of the perpendicular,

From the farthest limit of the shadow to DL, then up to the source and back to the shadow, forms a triangle. The third corner of the triangle will be called At, meaning "angle of light." DL may be the vanishing point of the shadow or the base from which it proceeds outward.

A SIMPLIFIED METHOD FOR GROUND SHADOWS

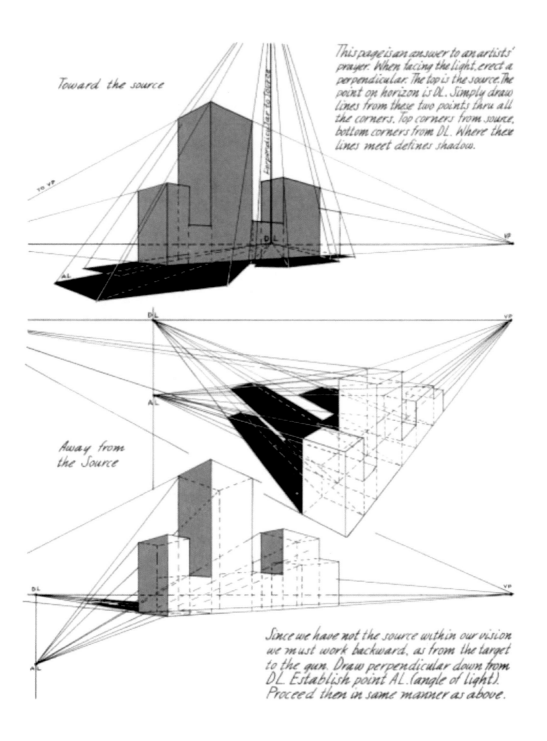

Toward the source

This page is an answer to an artists' prayer. When facing the light, erect a perpendicular. The top is the source. The point on horizon is DL. Simply draw lines from these two points thru all the corners. Top corners from source, bottom corners from DL. Where these lines meet defines shadow.

Away from the Source

Since we have not the source within our vision we must work backward, as from the target to the gun. Draw perpendicular down from DL. Establish point AL. (angle of light). Proceed then in same manner as above.

LIGHT AND SHADOW

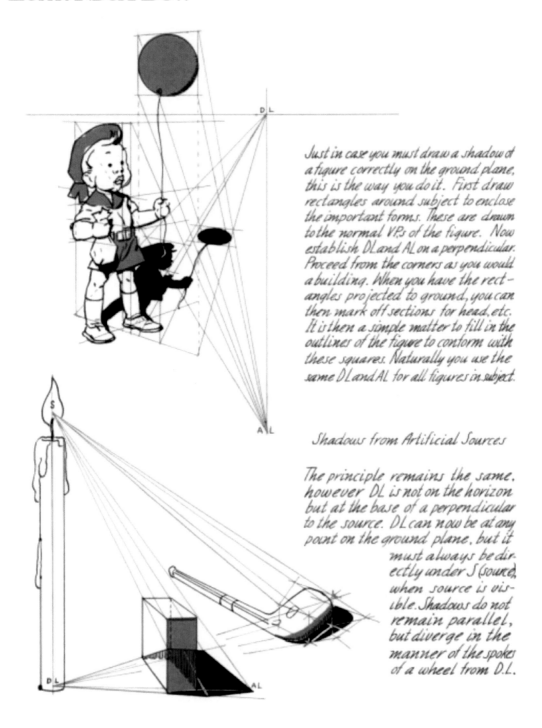

Just in case you must draw a shadow of a figure correctly on the ground plane, this is the way you do it. First draw rectangles around subject to enclose the important forms. These are drawn to the normal VP.s of the figure. Now establish DL and AL on a perpendicular. Proceed from the corners as you would a building. When you have the rectangles projected to ground, you can then mark off sections for head, etc. It is then a simple matter to fill in the outlines of the figure to conform with these squares. Naturally you use the same DL and AL for all figures in subject.

Shadows from Artificial Sources

The principle remains the same, however DL is not on the horizon but at the base of a perpendicular to the source. DL can now be at any point on the ground plane, but it must always be directly under S (source) when source is visible. Shadows do not remain parallel, but diverge in the manner of the spokes of a wheel from D.L.

The candle and street lamp work on the identical proceedure. Note the circle of shadow under the lamp, and how it was obtained. Figures are established in usual manner. The approximate area of light and shadow is indicated on the figures. This explains the wheel and spokes idea at DL at base of lamp.

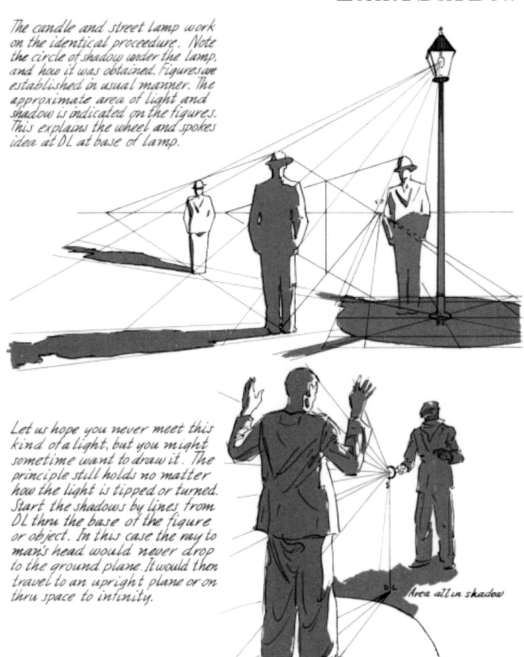

Let us hope you never meet this kind of a light, but you might sometime want to draw it. The principle still holds no matter how the light is tipped or turned. Start the shadows by lines from DL thru the base of the figure or object. In this case the ray to man's head would never drop to the ground plane. It would then travel to an upright plane or on thru space to infinity.

DL Area all in shadow

LIGHT AND SHADOW

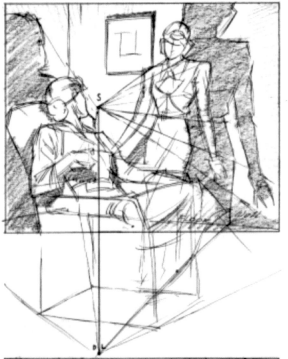

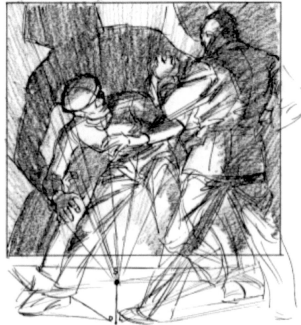

When the source of light is outside of the picture limits.

Let us assume in the top sketch that the source is in front of the picture plane. The best way then is to make a sketch, allowing enough room at the bottom to complete the figures roughly and enough of the floor to establish DL. If the shadows are to fall on a wall, draw the Floorline of wall. Carry base lines to where they intersect line of wall, then carry lines up vertically. Now pick points on figure and run lines from S thru these points until they meet the lines you brought up from the floor.

The bottom sketch shows the source below the picture plane and almost on the floor. For many subjects this gives a very dramatic effect. The shadows not only create interesting patterns, but intensify the action and the story to be told. This method is an excellent and practical way to plan a picture of any kind. A pen was used to sketch in the figures and a soft pencil to determine the effect of the shadows.

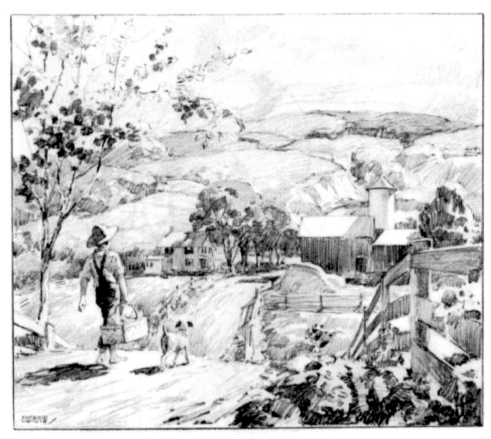

THE LAST HILL

I have a chosen a problem here that would be very difficult without some understanding of the fundamentals given in Part Three. By the use of perspective, together with the effect of light and shadow, we create the illusion of space, form, and a quality of existence.

This drawing may have the "feel" of having been sketched from life, because of the fundamental principles applied to it. However, it was done from the imagination, without any copy, simply to show you the possibilities.

It is a great storehouse of material. By all means, draw from that great source. Do not just copy. "Build" with what you observe for yourself to be true. Try to get the individual quality of each thing you draw. It is that quality that makes the artist interesting.

TIME'S UP, FOLKS. WE GOTTA GO. 'BY.

THE AUTHOR'S CORNER

I guess all you folks will forgive me for reserving a tiny corner of the book as my own. Everything must eventually come to an end, and so with this book, my first effort of this kind. It has been a concentrated effort. At times I have seen the daylight fade and come back again without sleep. I'll never tell anybody the actual time it took me to make these (it seems) thousands of drawings. I'm sure he would not believe me. I'm dreadfully tired but immensely happy. It has been intensely interesting, for I have retraced the ground of years ago. It has carried me back to the first struggle for knowledge that might earn me a living. It has reminded me of the early drawings which so often came back.

How simple it all might have been, had I in the beginning been able to assemble these working principles, put them in order, and work with them as I do now. But they were bits of knowledge plucked out of the air like bits of fluff from a seed pod. Only a few within your grasp, just a few to take root and flourish. Strangely, the simplest facts always are the latest in being understood. And when they are. Their utter simplicity is the best reason for their acceptance, even at the cost of having to sweep out the pet theories and ideas accumulated over half a lifetime.

At best, how do I know that I'm any more right now than in my student days? The answer is that of the convalescent who has suffered and got well again. Lack of knowledge can be greater torture than the effort of acquiring it. I know only that I am happier in my work than I was then. It has gained publication in places that once seemed hopeless for me. I can approach the work with peace of mind and confidence boon of experience. This book is an effort to transplant that peace of mind to some few thousand others who otherwise must fall victims to the selfsame devices which contrive to make before they can make even a meager start.

WHEN ALL IS SAID AND DONE, NATURE IS YOUR BEST INSTRUCTOR

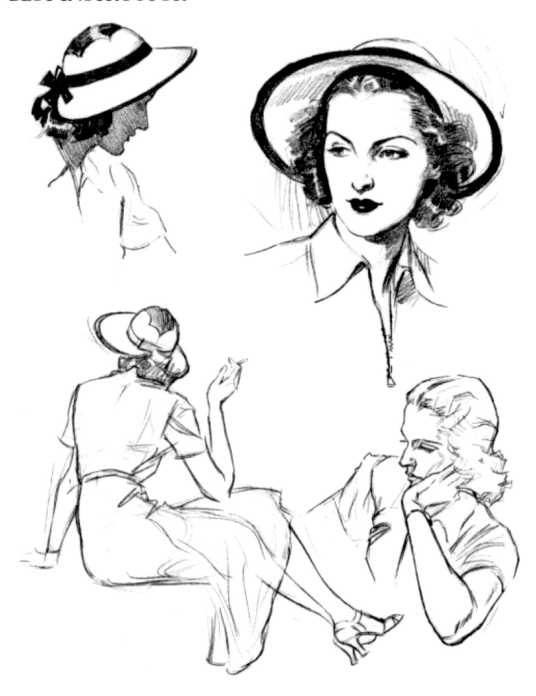

When sketching from life,
the most practical way is
to hold pencil or ruler at
arms length and by sight-
ing, locate middle point
of your subject, both up
and down and across.
Approximate rectangle
the subject will fit into,
and draw this divided as
above. Now by remembering
just where middle point
fell, you can sight again
for quarter divisions first
block in big shapes to fit
points, then block in the
smaller forms. Draw the
shadow shapes and fill in.

PENCIL
SKETCH OF MY
DAUGHTER

ANDREW
LOOMIS

I can think of no field of endeavor so sadly lacking in simple organization of its working principles. Nothing quite so haphazard, hit-or-miss, as the whole field of artistic endeavor. I am not a cartoonist, but I choose caricature for the beginner: principally because there is fun in it, and from the start I want him to feel a little of the creative joy he is entitled to. When artists begin to compile and set down their combined experience, give freely and humbly what little they can add, as do the other sciences, then art may have some chance to reestablish itself in the hearts of everyday people even against the mechanical perfection of the camera; even in a period of social adjustment and financial depression. The mental depression of our era weighs heavier on our race and future than do our dollars or lack of them. A little joy from the inside must be welcome to almost anybody. Perhaps my book is a step in that direction.

Yes, folks, I'm tired, but I'm happy. My little job, feeble as it may be, is done. I wait as breathlessly to see how you will like it as 1 ever waited for the verdict of any art editor or director. I'd give many more sleepless hours just to feel with you that first thrill of having created

even if it be mere lines of a pencil. You'll get to love those little folks you draw, even if they are a bit unwieldy and only a little bit human.

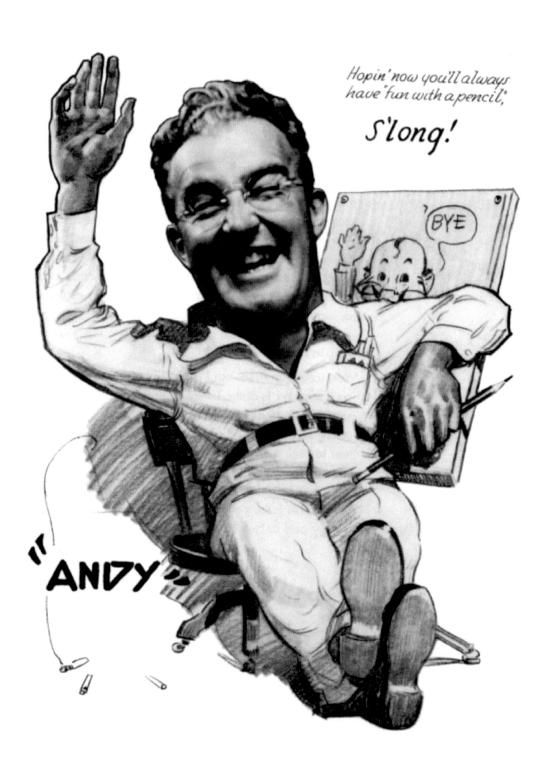

THE END

Made in the USA
Las Vegas, NV
13 March 2021